Flight Attendants // Brian Finke

Life Vest Under Your Seat
Fasten Seat Belt While Seated

11-0434-538

Flight Attendants // Brian Finke

Introduction // Alix Browne Text // Alison Nordström

pH **powerHouse Books** Brooklyn, NY

Brian Finke spent two years flying around the world—without any real sense of destination—logging what must have amounted to hundreds of thousands of miles, to photograph the lives of international flight attendants both on duty and off. That he was able to do so in a security delay/lost baggage/lack of service/post-9/11-world says as much about his ambitions as a documentarian of contemporary culture as it does about his patience and charm as a human being.

A previous body of work found Finke trailing exuberant squads of American cheerleaders and football players—a project for which he no doubt spent a lot of time on busses. In the flight attendants, the photographer has discovered another nomadic tribe, distinguished by its own language, mannerisms, and uniforms. But what struck Finke most were not the differences between these two seemingly disparate groups, but rather the similarities—in their efforts to maintain the front of camaraderie, in their performance of choreographed activities, in their elaborate codes of appearance.

The personification of the glamour and promise of a world in which people soar through the air—a gin-and-tonic in hand—from point A to point B, flight attendants have long occupied a privileged spot in the minds of both air travelers and the airline industry itself. The very first stewardesses (as they were called well into the 70s) were registered nurses, hired as an experiment in May of 1930 by Boeing Air Transport under the leadership of Ellen Church, who had approached the company with the dream of becoming a pilot. These industry pioneers were uniformed to exude a sense of both caring and competence (hats, capes) and cast as much for their skills as their physiques—the reasoning for which was, apparently, as pragmatic as it was aesthetic. Stewardesses had to be tall enough to reach overhead lockers with ease, yet petite enough to navigate confined cabin quarters and narrow aisles. They also had to be single enough so as not to elicit calls from perturbed husbands wanting to know why dinner was not on the table. In those early days of commercial air travel a flight from San Francisco to Chicago in a 12-seat biplane minimally retrofitted for human transport could reportedly take 20 hours and include as many as 12 stops for refueling of aircraft, crew, and human cargo. It is testament to the grasp

the dream of travel by air has had on the popular imagination that people didn't just walk.

In its heyday, the job of stewardess (with a mandatory retirement age of 35 upheld through the 60s it could scarcely be thought of as an actual career) was second only to that of Hollywood starlet in terms of allure. Being a stewardess was a direct route to broader horizons—like a good marriage. (The profession in fact boasts numerous models, actresses, and Miss America candidates among its ranks.) Airfares were subject to government regulation until 1978, and as the industry grew, carriers began to recognize the value of their flight crews to help distinguish them from their competition. Uniforms came to reflect fashion trends—miniskirts, hot pants, catsuits—or were commissioned by well-known fashion designers like Bill Blass, Emilio Pucci, or the French couturier Pierre Balmain who was hired to update the look of the Singapore Girl in the early 1970s. Cheeky ad campaigns like Continental's "We Really Move Our Tails For You," hinted at the level of service one could expect to encounter in the oh-so-friendly skies.

Women who might have been attracted to the job because of this very image of glamour, freedom, and independence, found that it ultimately served to undermine their authority and compromise their ability to perform their duties. The old adage about Ginger Rogers, and how she could do everything Fred Astaire did only backwards and in high heels, is implicit in the flight attendants' plight. As Kathleen M. Barry, the author of *Femininity in Flight: A History of Flight Attendants* (Duke University Press, 2007), observes, "From the first job interview onward, stewardesses were expected to remain perfectly groomed, maintain a willowy figure, and conjure an unending supply of cheer and concern for passengers." Fighting for wages commensurate to their skills and to be taken with a level of seriousness on par with their professional responsibilities, flight attendants eventually found themselves at the center of feminist debate. "I don't think of myself as a sex symbol or a servant," went the common defense. "I think of myself as somebody who knows how to open the door of a 747 in the dark, upside down, and in the water." And yet, in one particularly telling image from 1965, TWA stewardesses protesting for better pay and shorter hours look like an advertisement for the airline—immaculately uniformed, coiffed,

made up, smiling!—picket signs clutched in their gloved hands.

In a time of both marked increases in security and decreases in service, modern day travelers are hardly in the position to be picky when it comes to which airline has the prettiest flight attendants or the nicest uniforms. The hope is that you, and perhaps even the bag you checked, arrive at all. Today's flight attendants remain, by and large, a civilizing force, a literal reminder to fasten your seatbelt and raise your tray table, but also a symbolic one that we intrepid travelers are more than just human cargo—well, at least until the 500-passenger Airbus A380 officially takes to the skies. In that respect, neither their social role nor their image has changed all that dramatically. Many of the airlines Finke frequented are from countries that continue to perpetuate the stereotype of the unflappably glamorous flight attendant, not to mention that stereotype's attendant nostalgia for the golden days of air travel. Flight attendants from Cathay Pacific, Air Asia, All Nippon, and Icelandair seem from another era when compared with those Finke encountered on, say, JetBlue or Hawaiian Airlines. The fact that Cathy Pacific had reinstated its iconic red uniforms in honor of its 60th anniversary might have something to do with this. But Singapore Air still actively promotes the charms of the Singapore Girl, lauded for engendering Asian values and hospitality and whom the airline likes to think of as caring, warm, gentle, elegant and serene.

Throughout Finke's flight attendant series, there are glimpses of what air travel has in fact become. Take, for example, the democratizing attempts of Southwest Airlines where the class hierarchy has been abolished and every day is casual Friday. Or the ill-conceived (and thankfully short-lived) in-flight entertainment concept, Hooters Air, where the uniform of orange short shorts and a tight white T-shirt emblazoned with the company logo brings the idea of casting flight attendants to meet certain size requirements to an entirely new level. In Finke's photograph, the Hooters air hostess holds the microphone to the public address system as if she is not quite sure what to do with it. (Somewhat reassuringly, the airline also employed "real" safety-trained flight attendants who were recognizable as such by their more modest attire.) A photo of a young flight attendant for Tiger Airways (a no-frills carrier

based in Singapore) practically hurling a plastic container containing a sad looking sandwich will come as an all-too-familiar sight to today's budget traveler.

Finke's approach in photographing these women—and the occasional man—is neither nostalgic nor unduly real. He neither glamorizes his subjects nor does he portray them in the glaring, unforgiving light that many of us have come to understand as documentary. For the most part, it is the flight attendants themselves who appear to cling to the glamorous promise of their profession (there are few beauty pageant contenders here; though one Southwest flight attendant is a part-time saleswoman for Mary Kay Cosmetics). We catch these women in their choreographed moments, familiar to the point of being generic—demonstrating safety procedures, smiling and waving as if in an advertisement. But Finke reminds us of their individuality, too. A candid photo of a red-uniformed Cathy Pacific flight attendant, shopping for a toothbrush in a company store, could be accompanied by a caption ripped from the celebrity tabloids: Flight Attendants—They're Just Like Us!

If, on occasion, a particular image comes across as slightly surreal—and here the photo of an Icelandair flight attendant in training, perfectly composed and not a platinum blonde hair out of place as she blasts a fire extinguisher at an overhead bin comes to mind—it is perhaps because no matter how commonplace the experience of air travel has become, flying is still something that inspires a certain degree of awe. Finke's photos contain in them every excruciating minute of the 18-hour haul from New York to Hong Kong. And yet, he somehow emerges with his illusions mostly intact. Even as we stand by and watch as the flight attendants shop for toiletries or grab a meal in the company cafeteria, or return home to the lives many of us cannot even begin to imagine they have, they maintain, in his photos and in our minds, their quintessential flight attendant-ness. It is as if we, and they, only exist in that unnatural vacuum-sealed experience, where even as you find yourself hurtling through the sky 36,000 feet above the earth at 600 miles an hour, time seems to stand perfectly still.

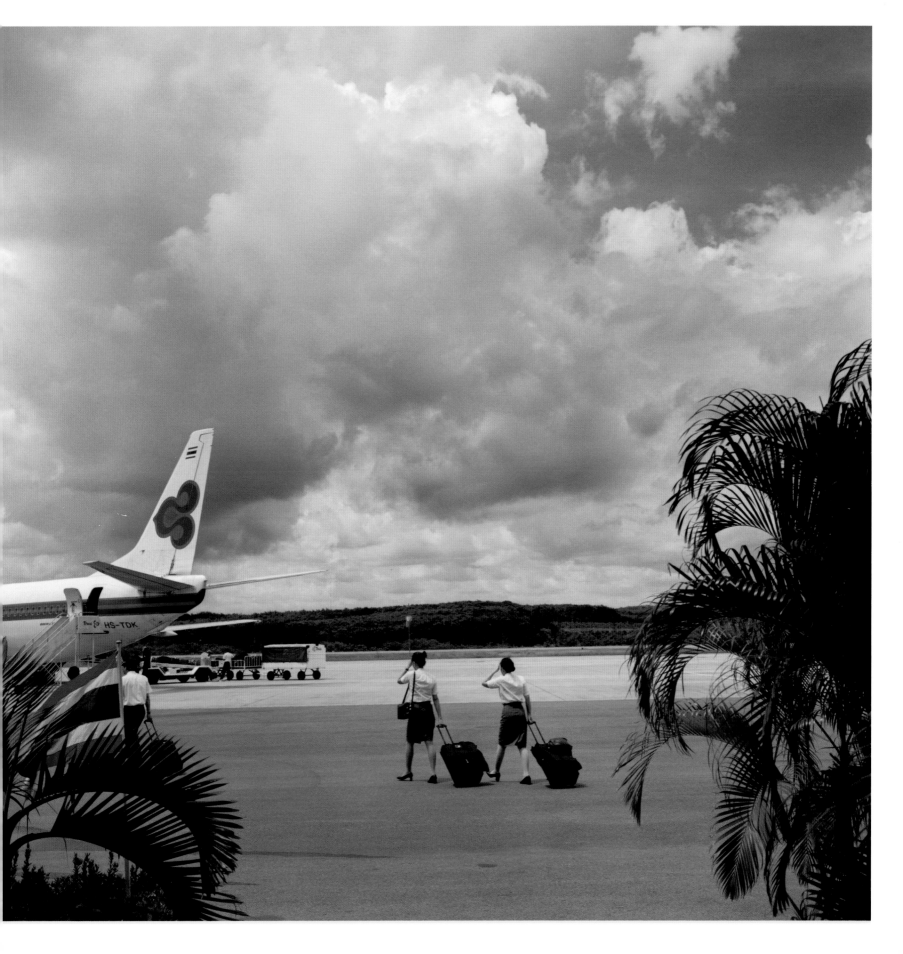

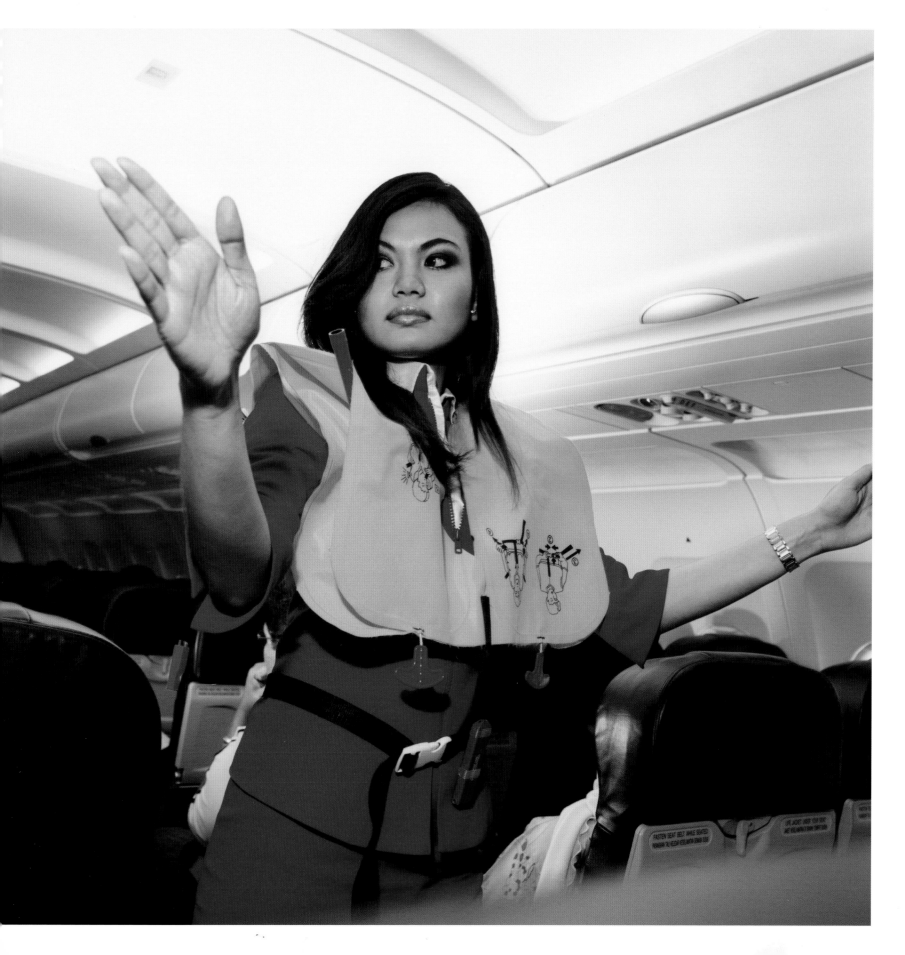

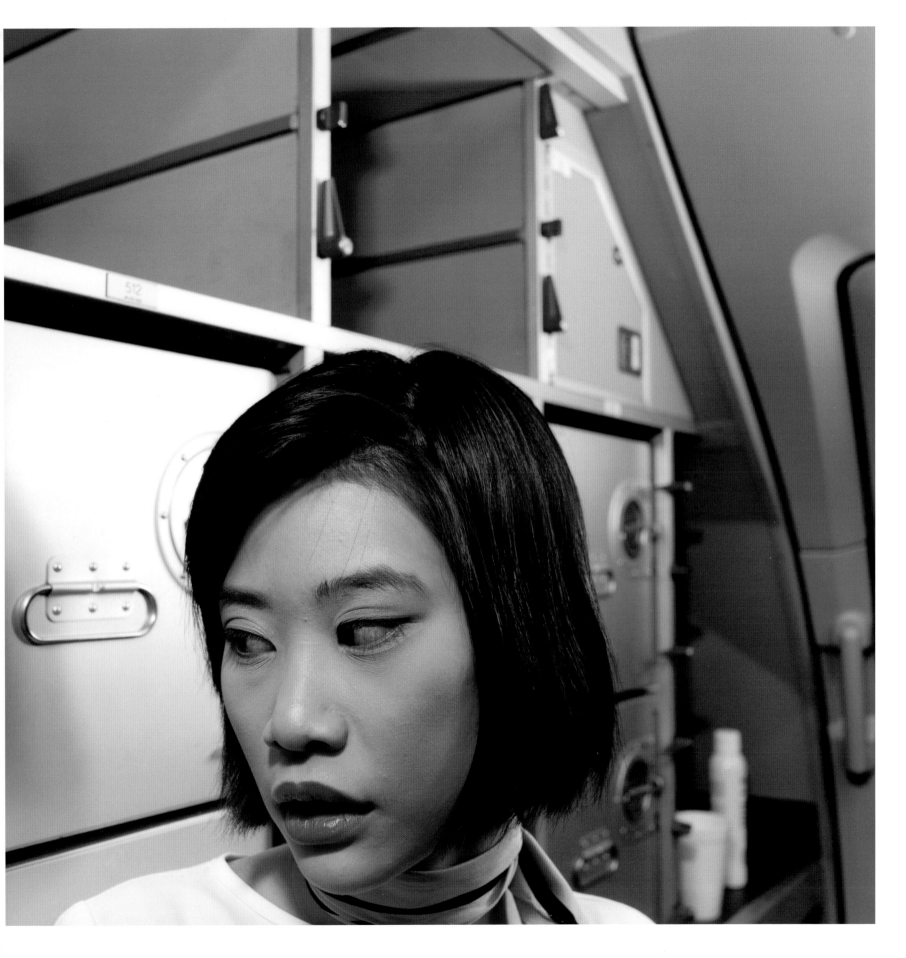

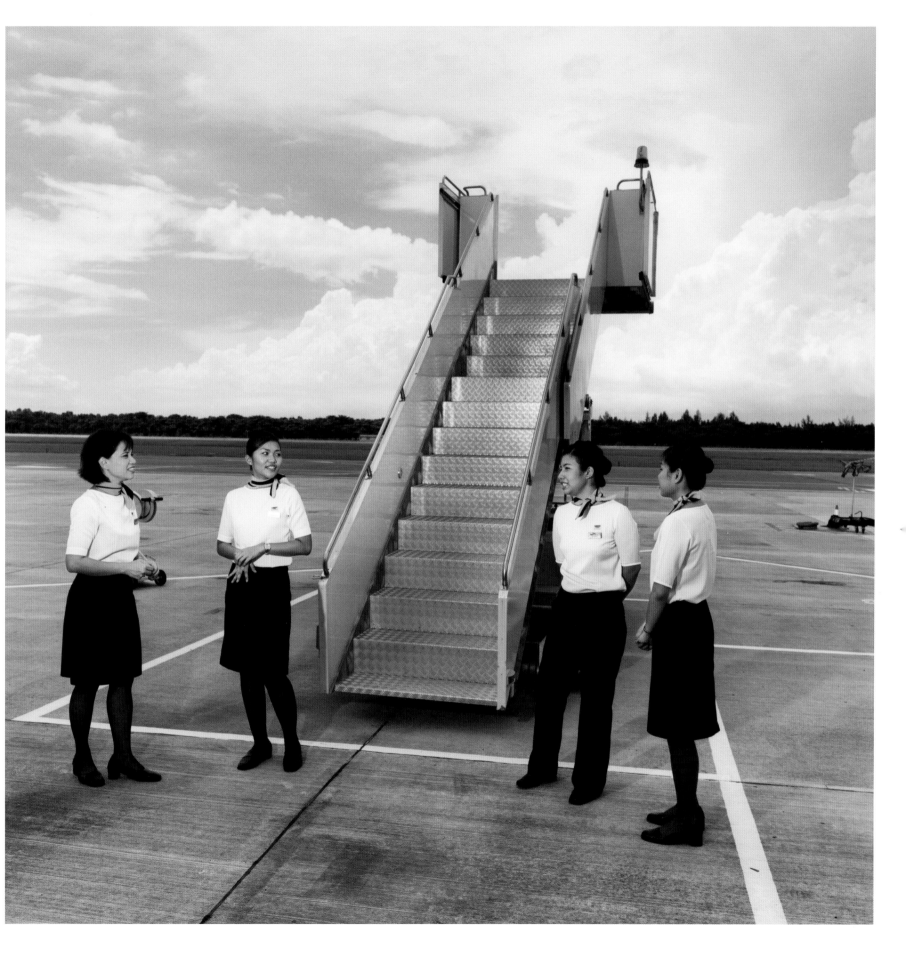

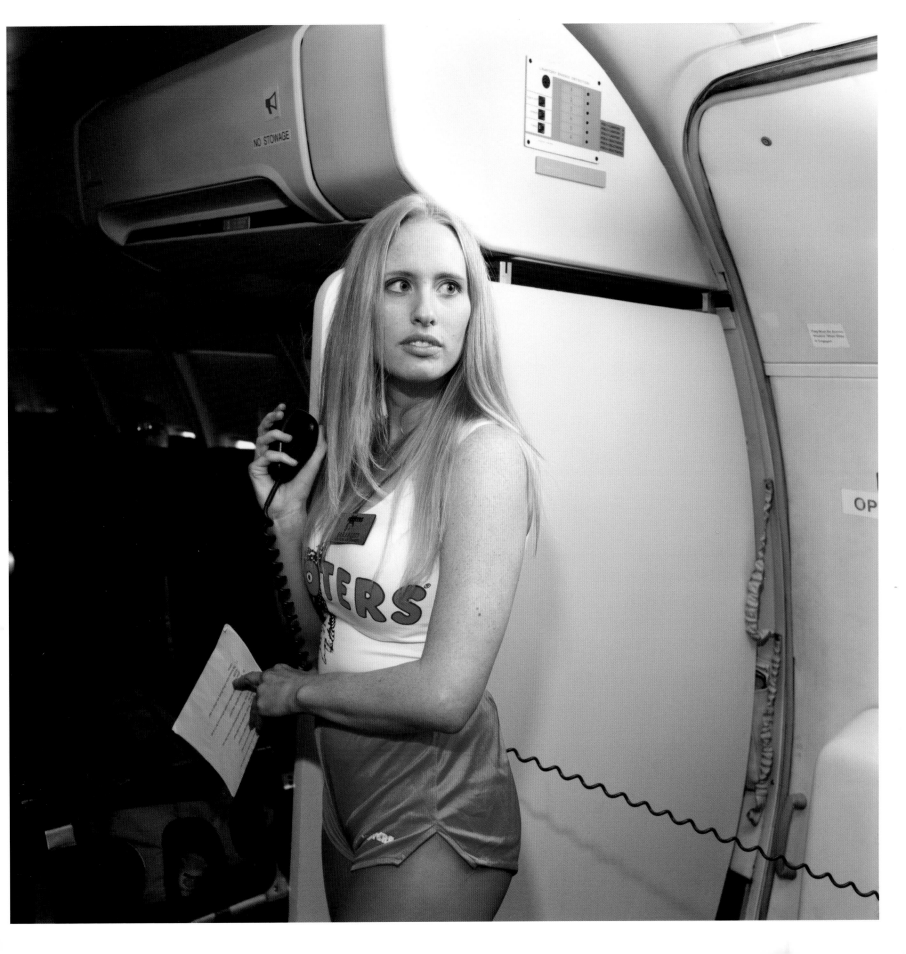

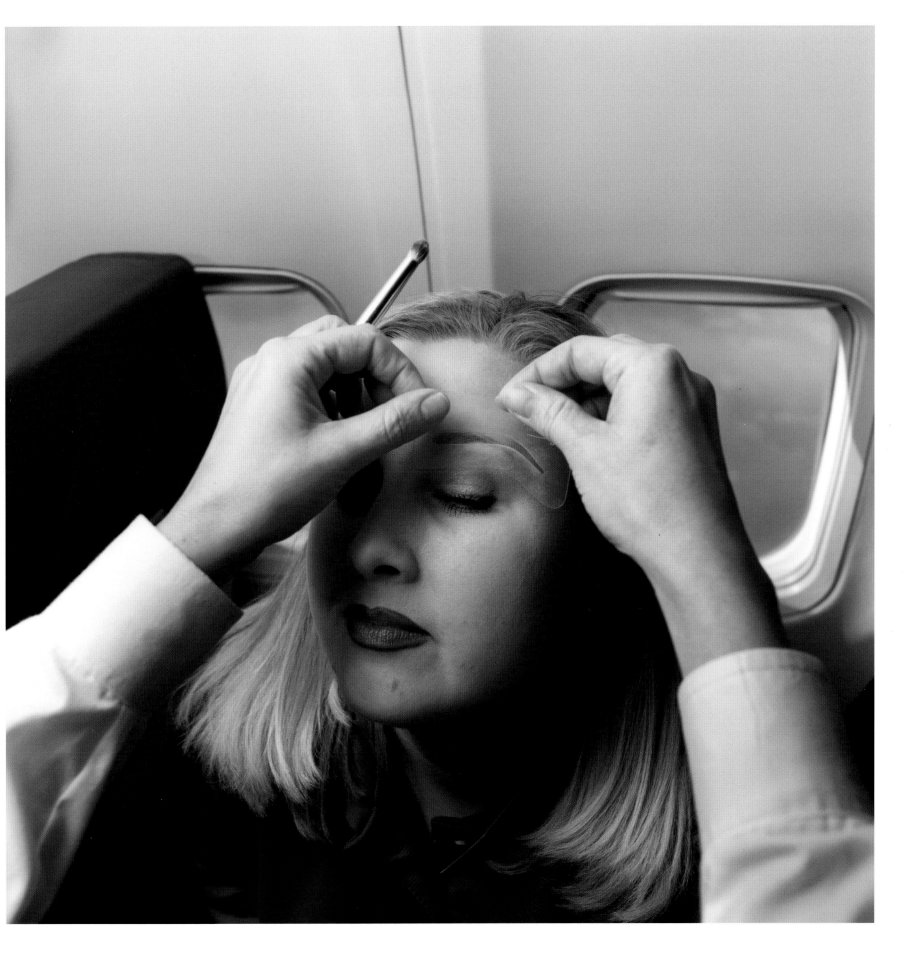

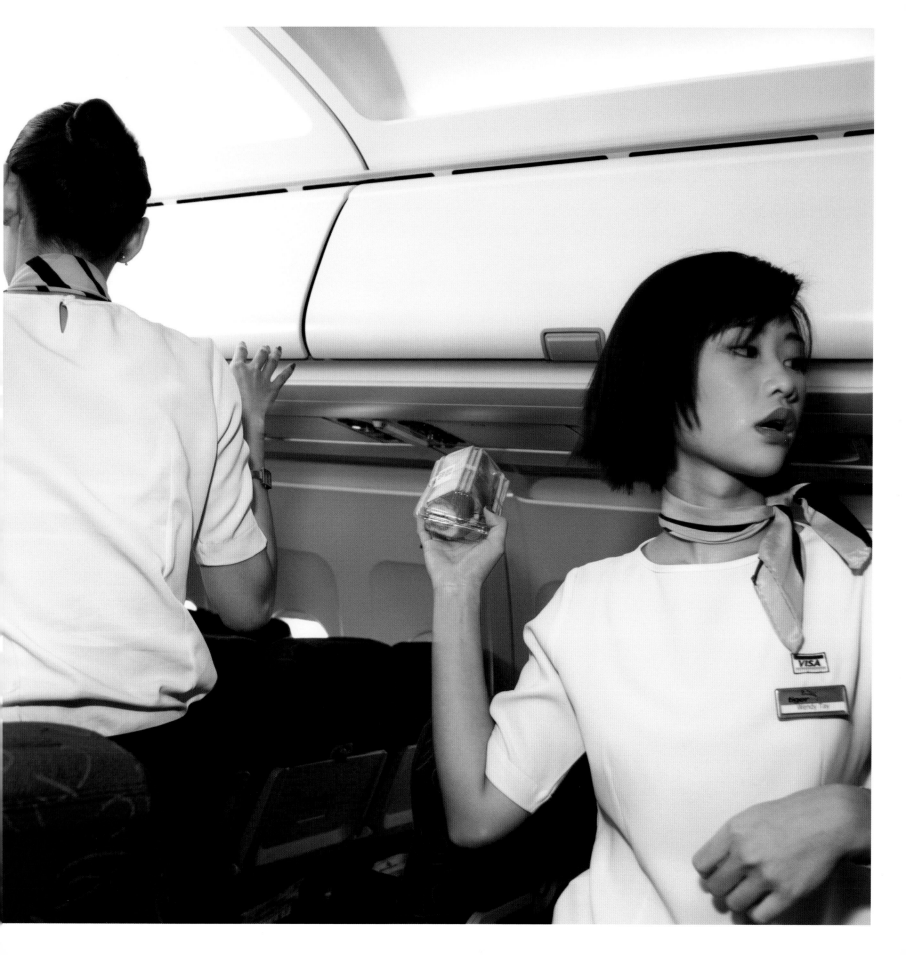

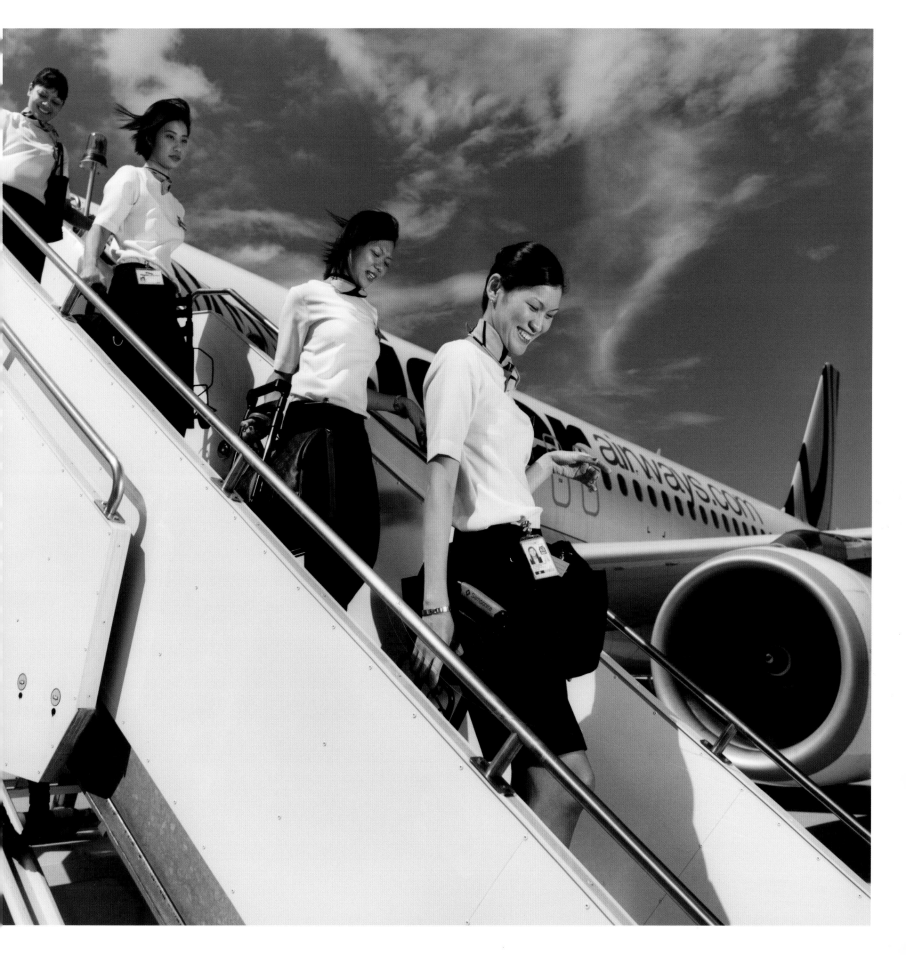

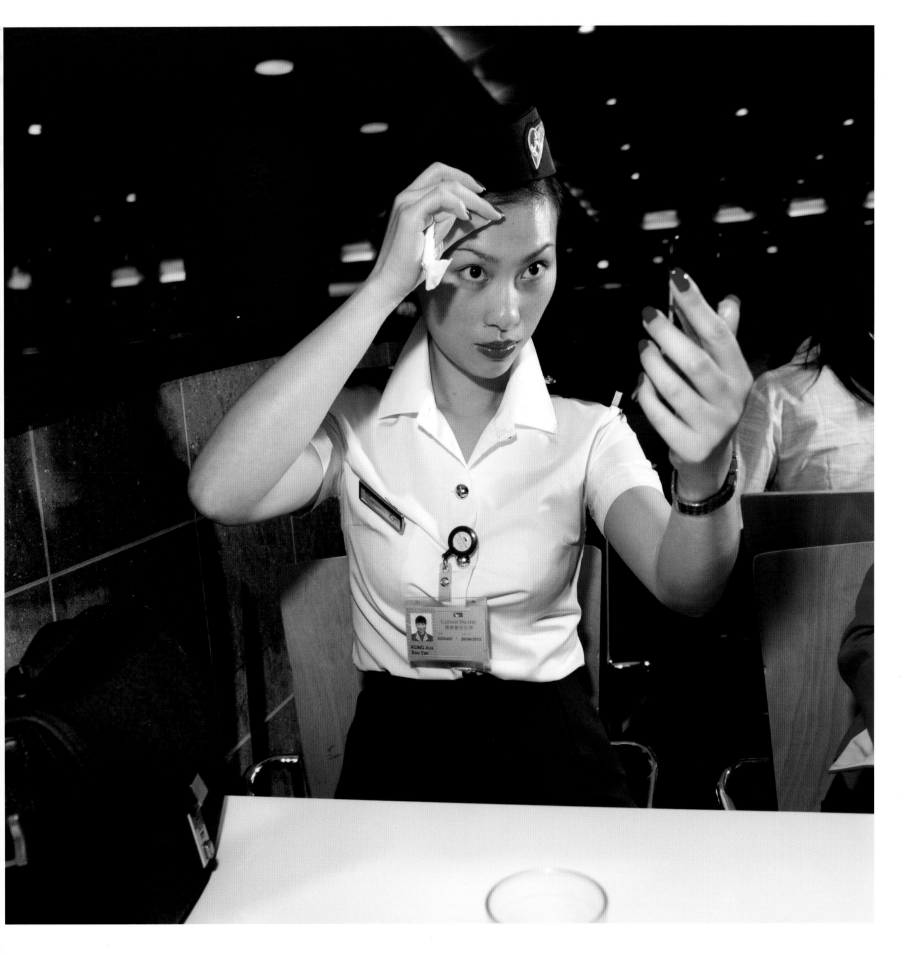

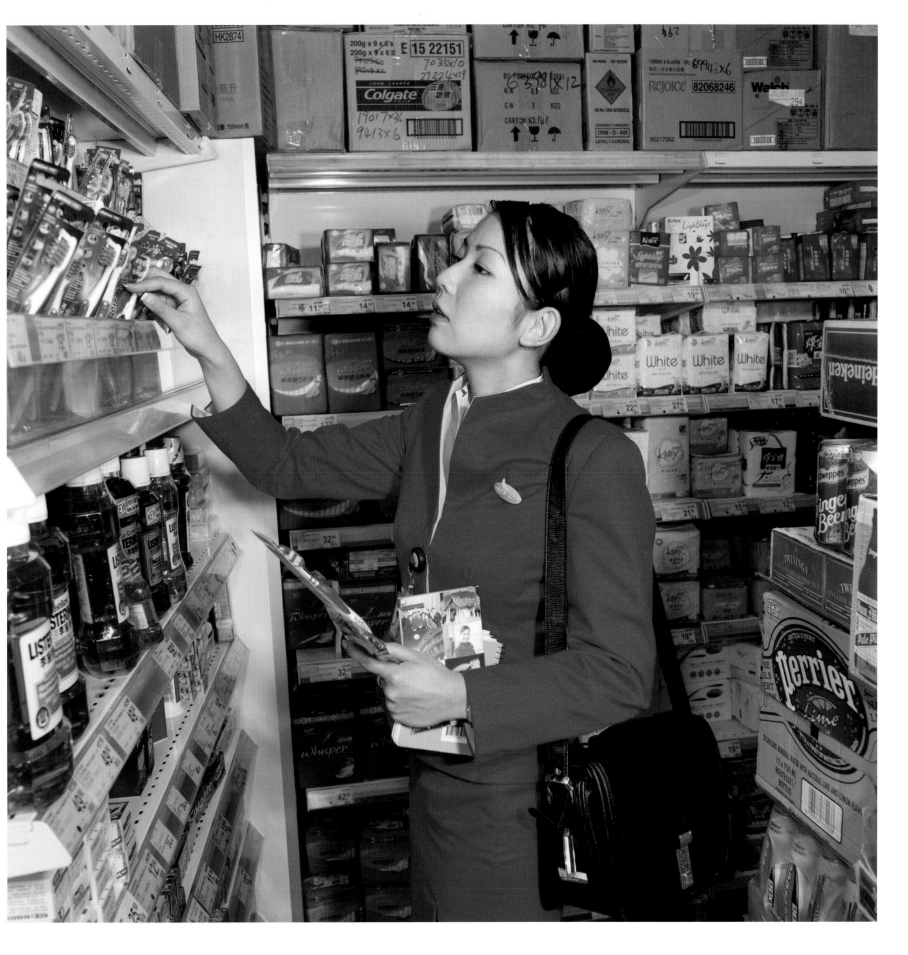

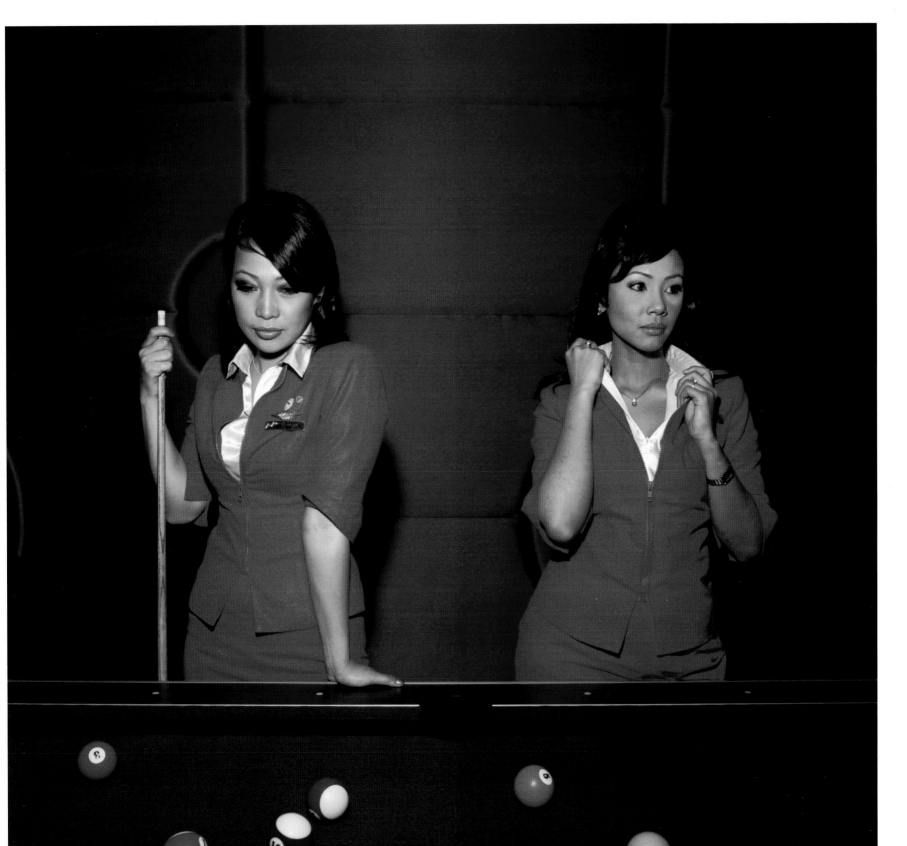

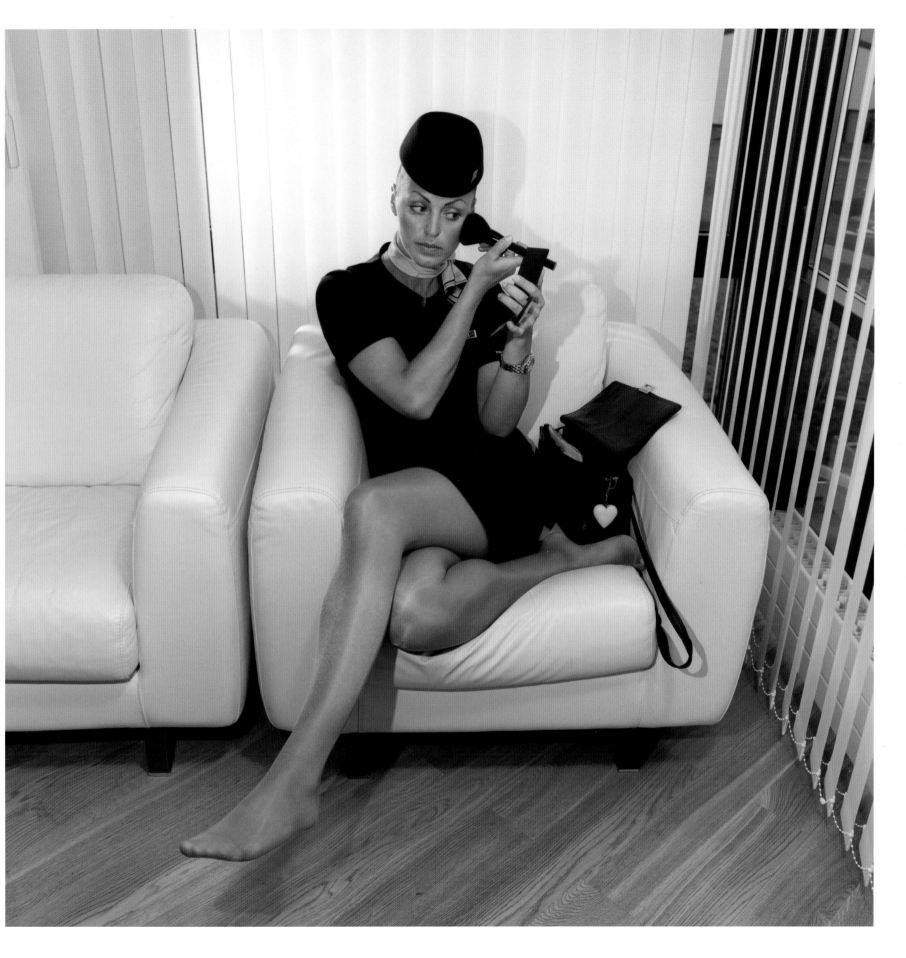

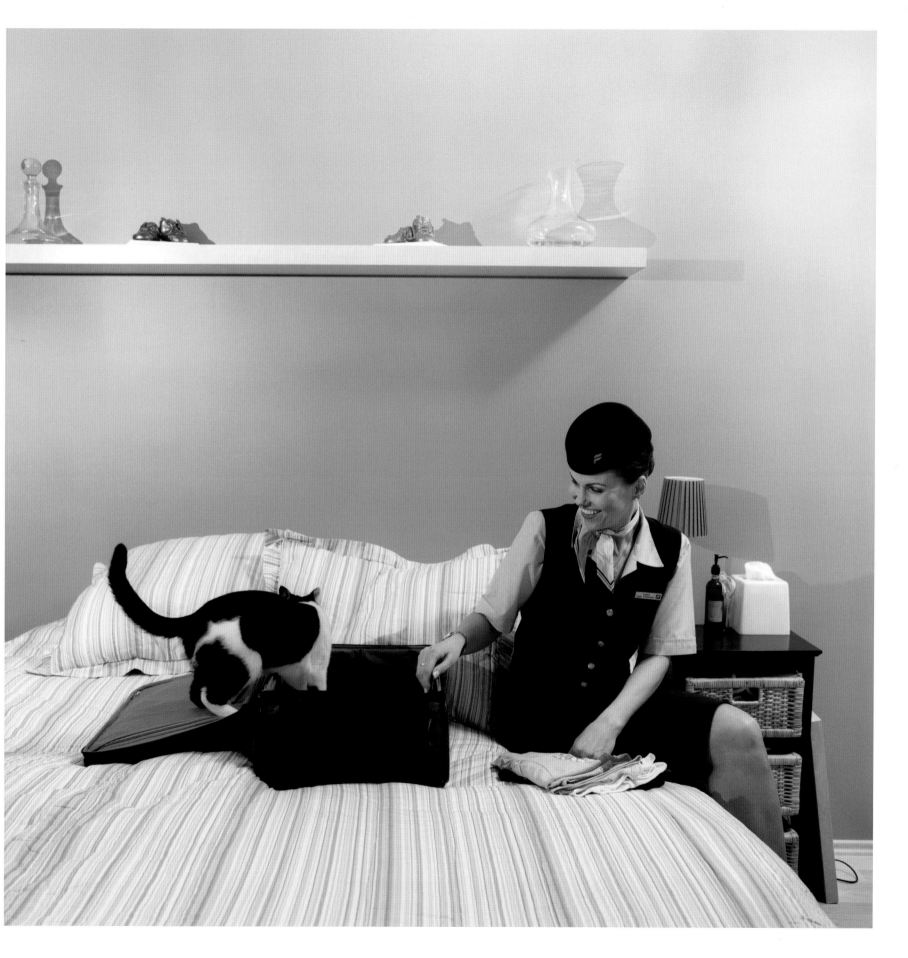

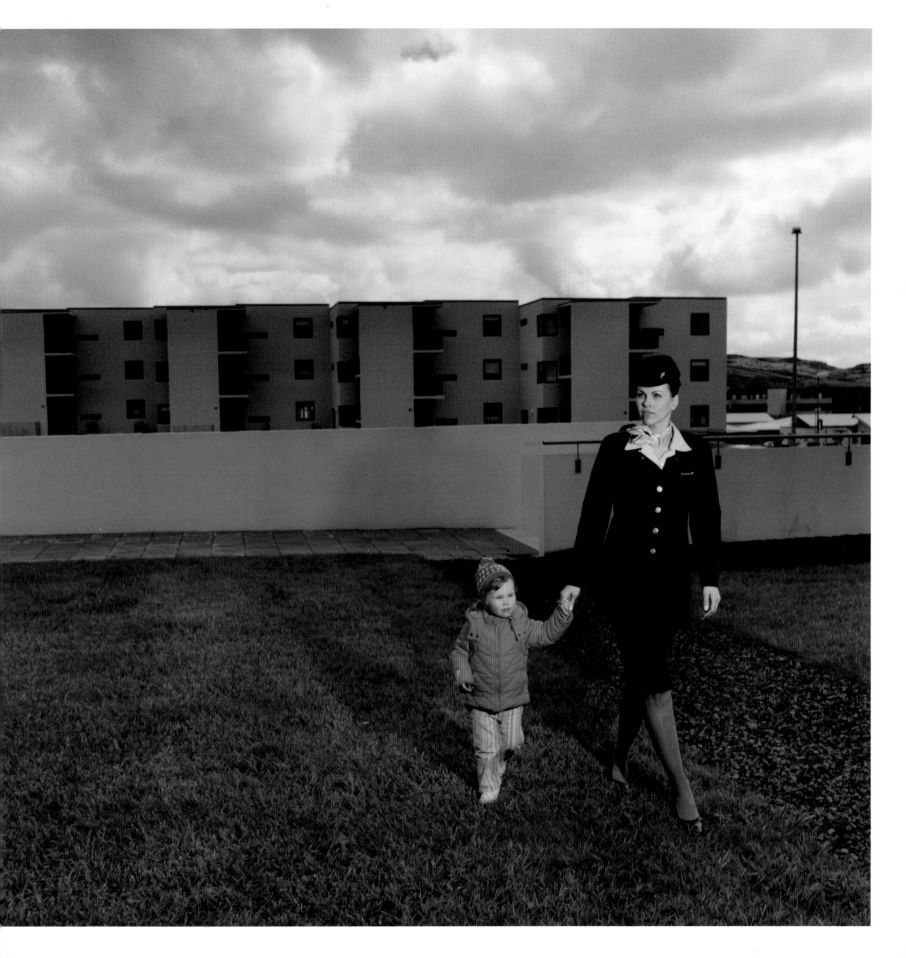

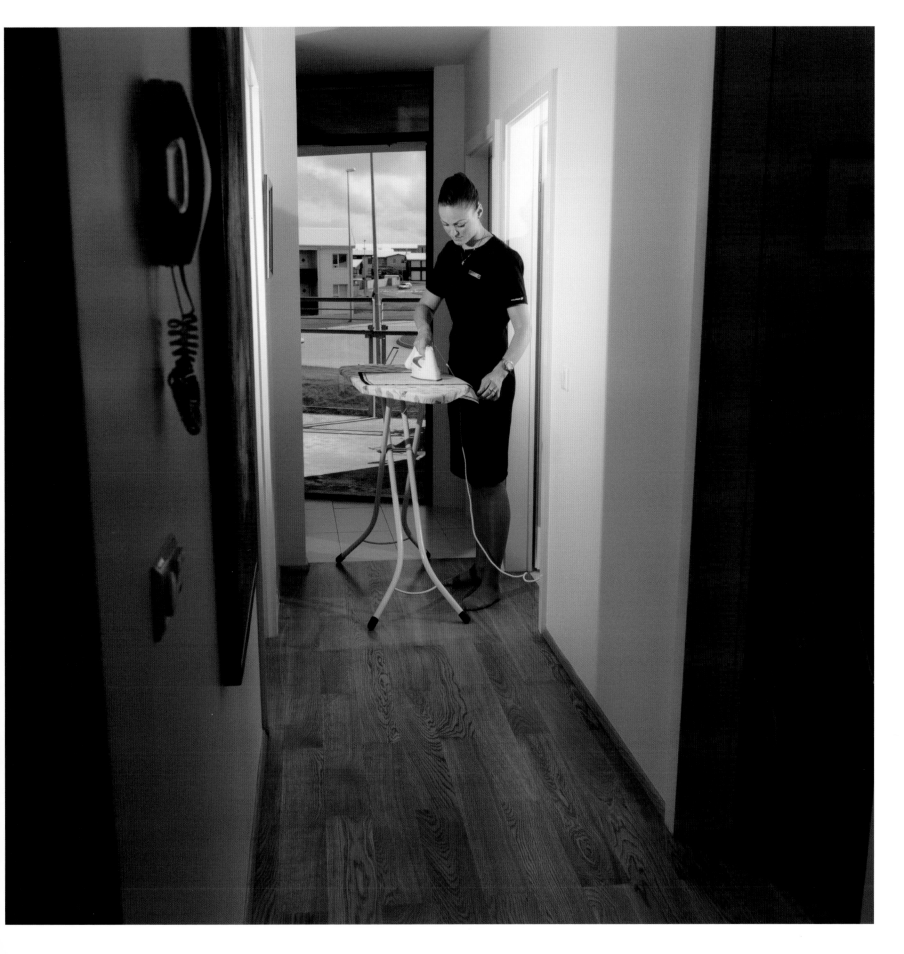

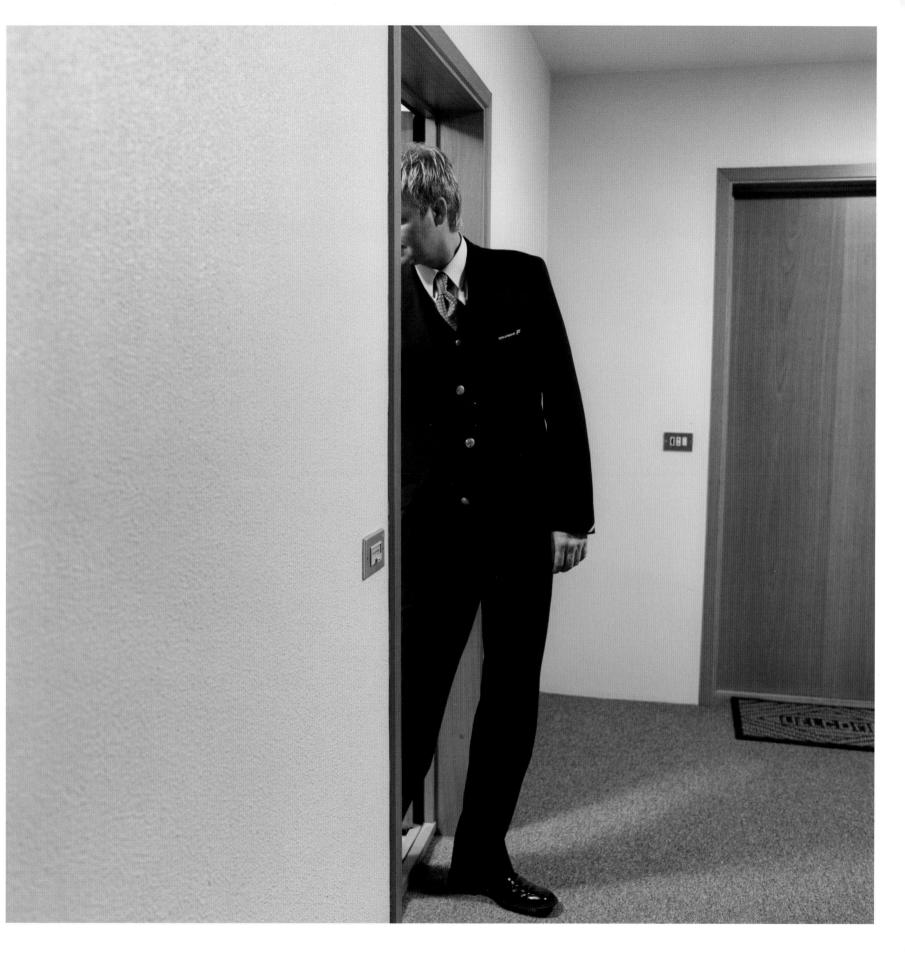

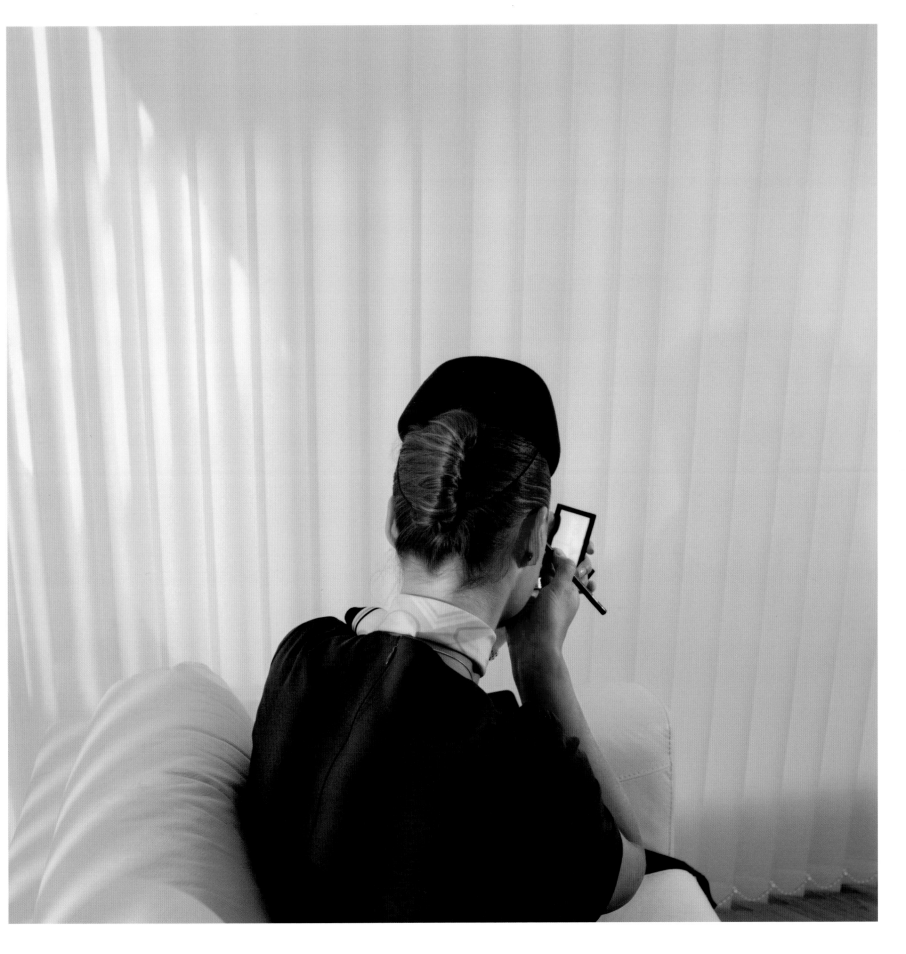

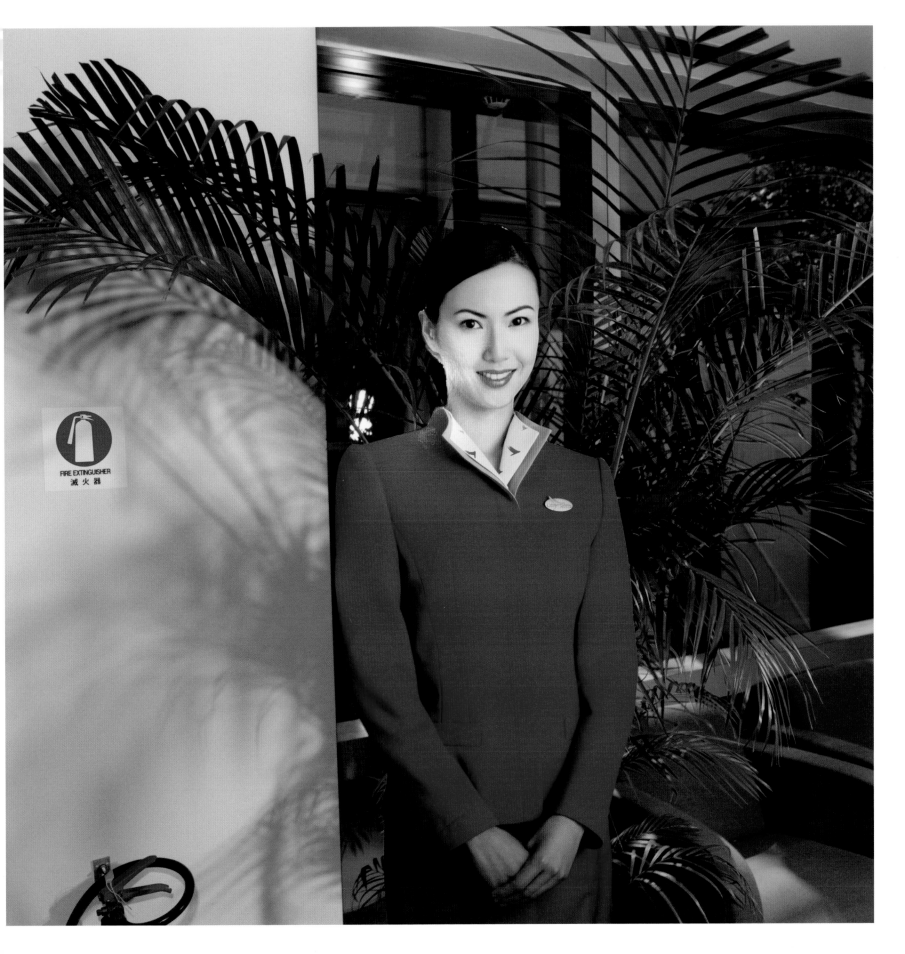

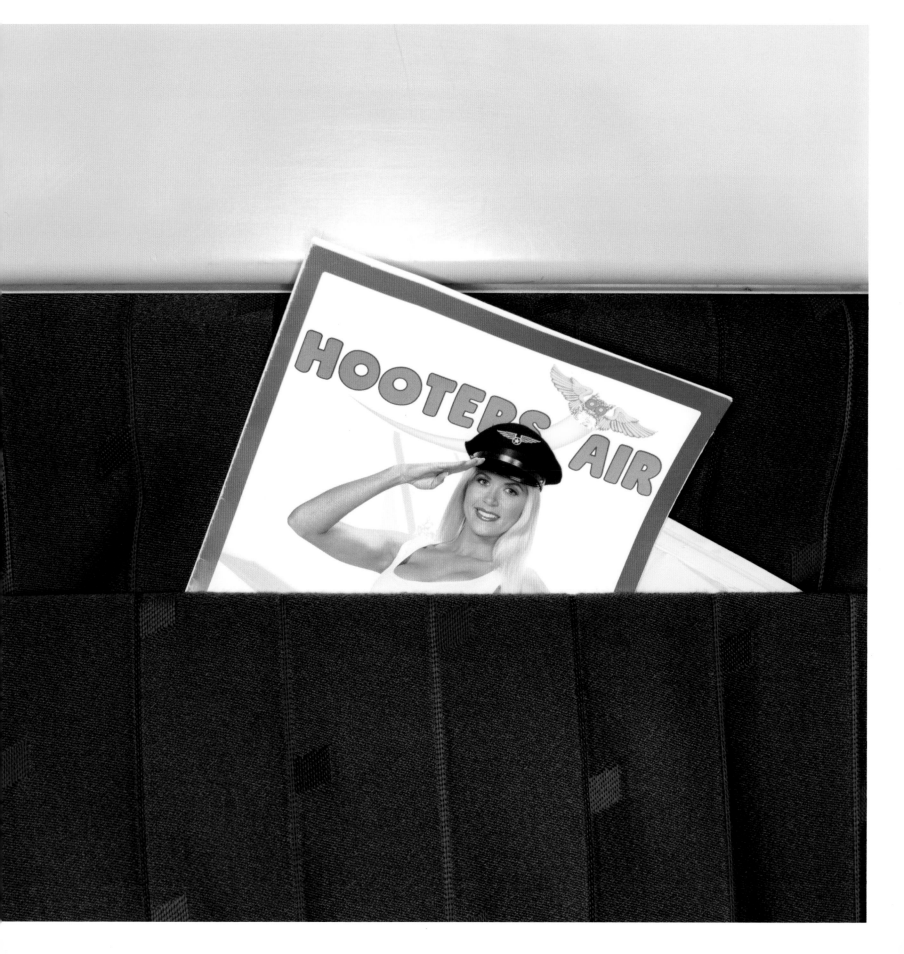

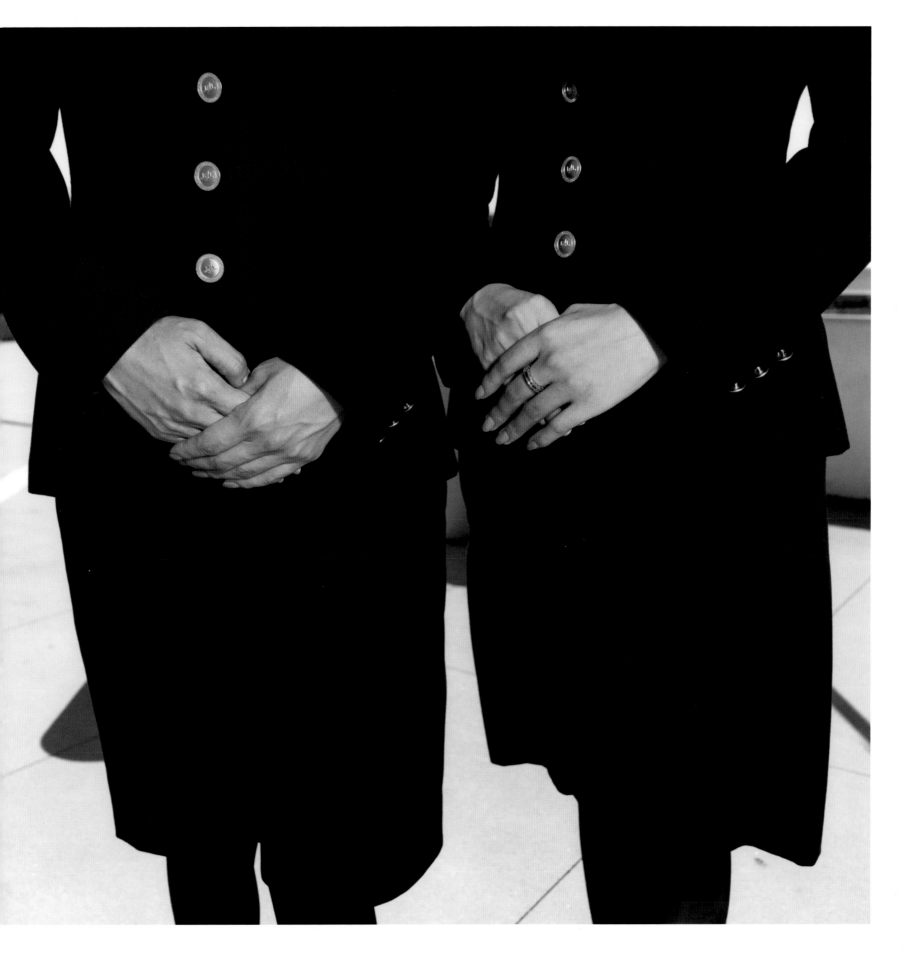

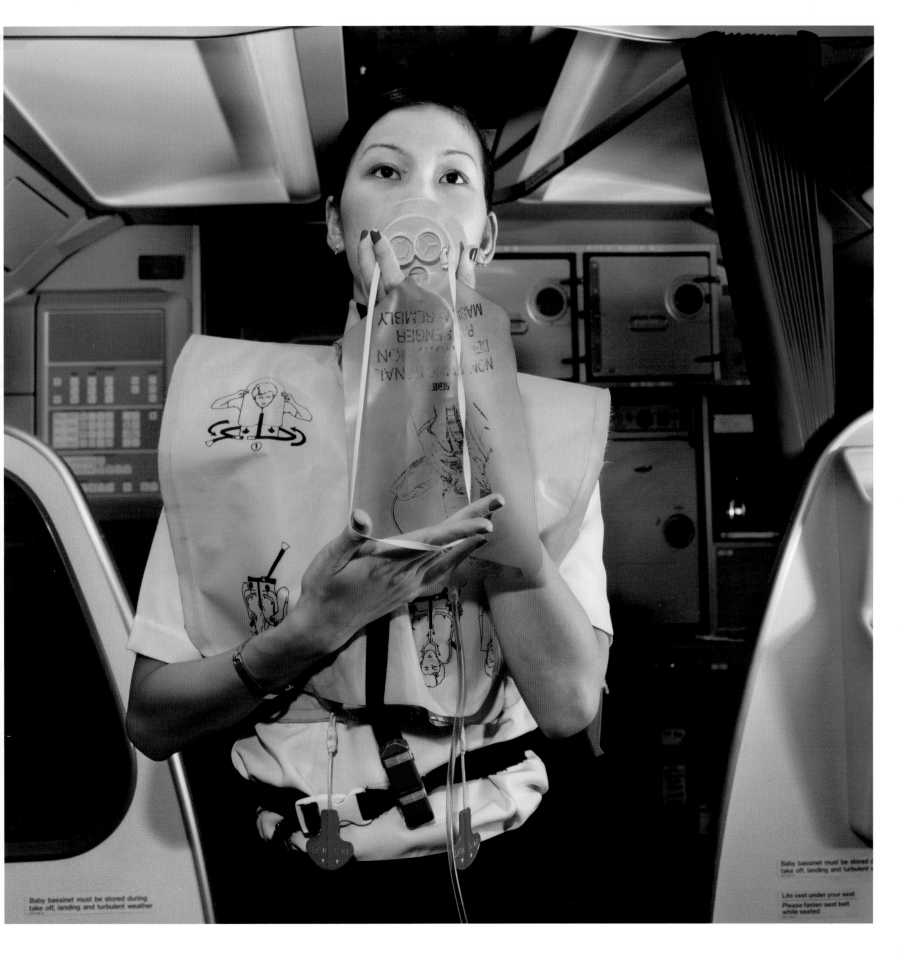

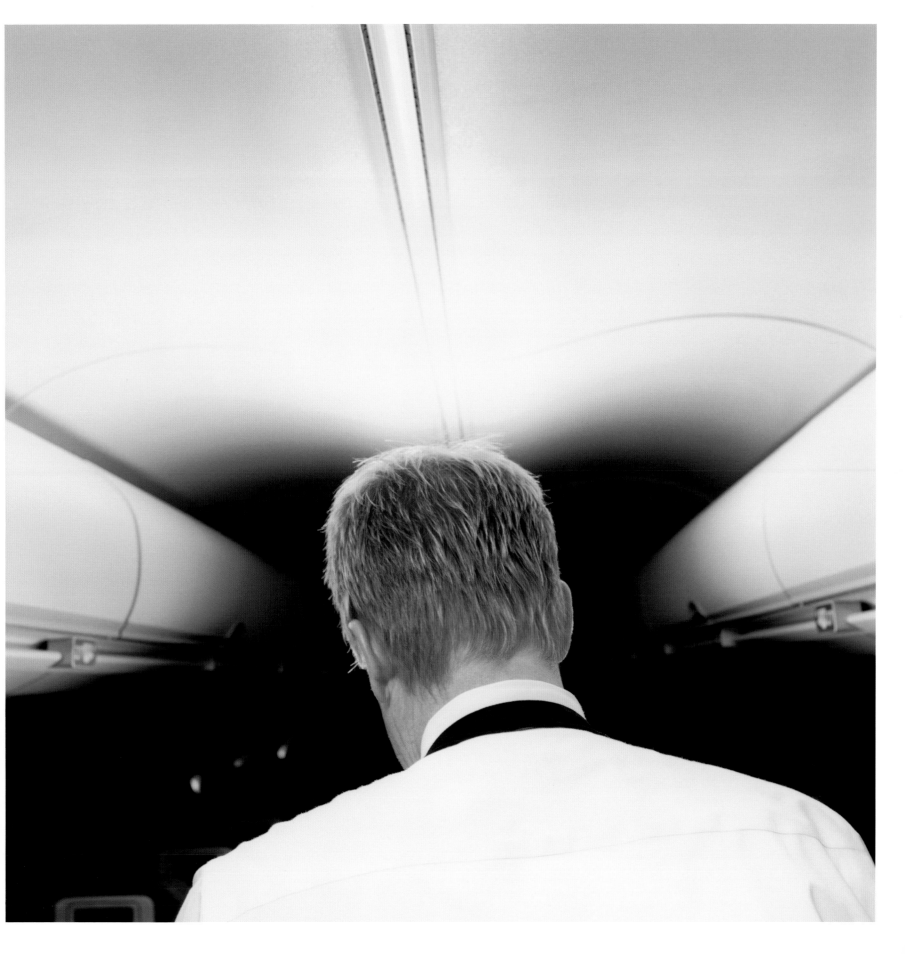

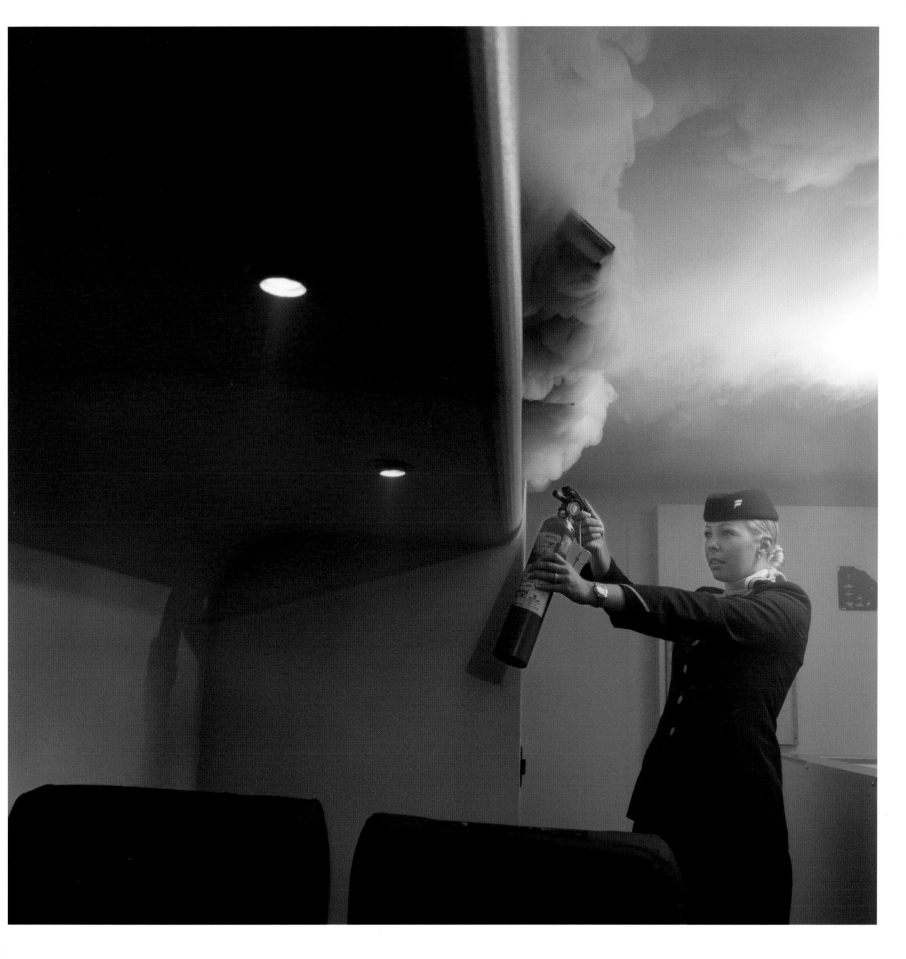

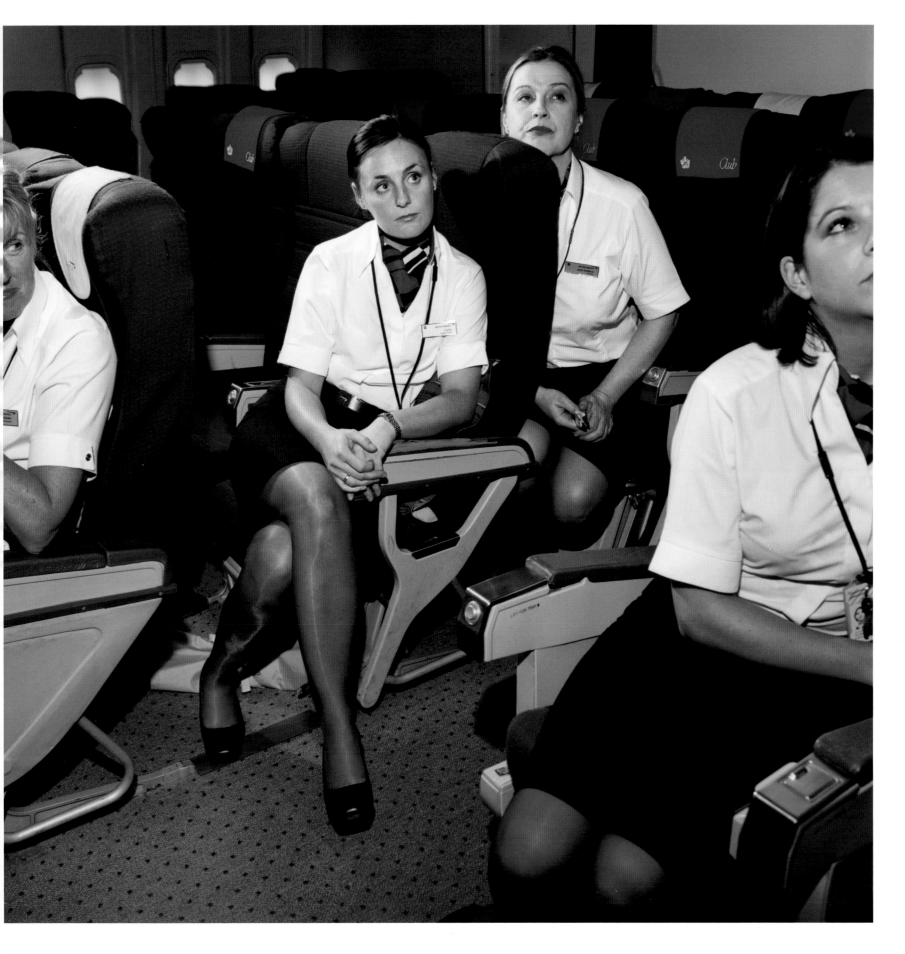

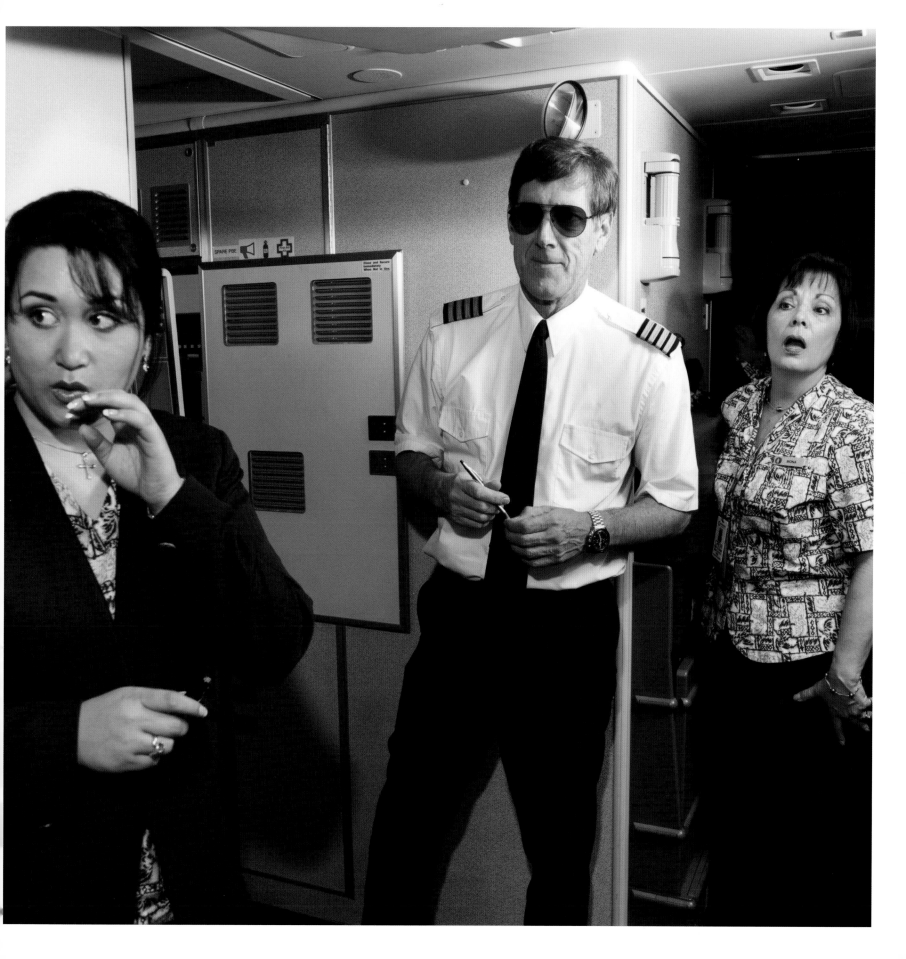

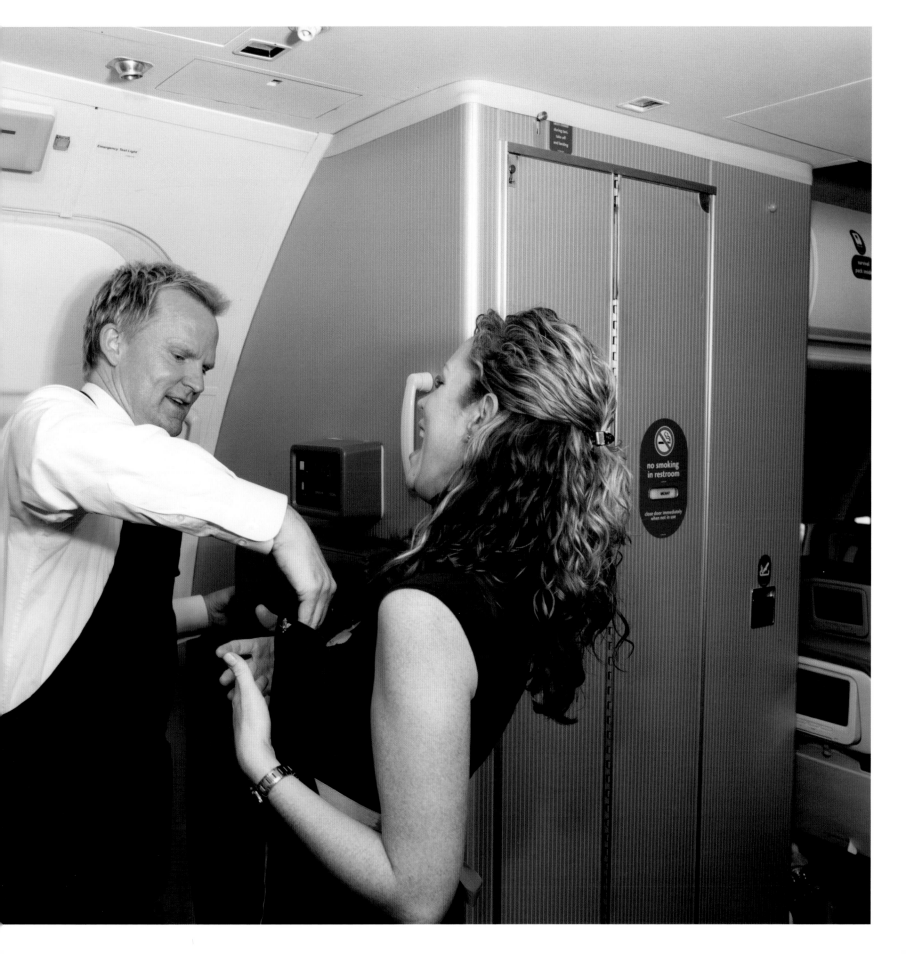

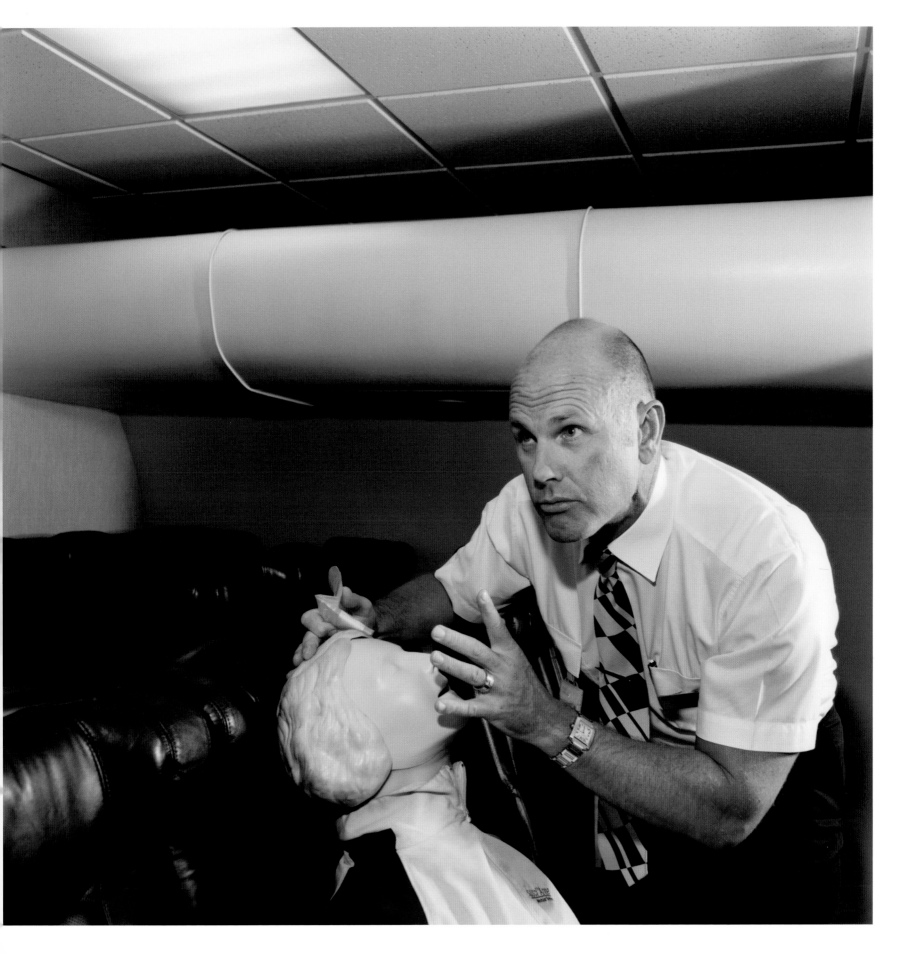

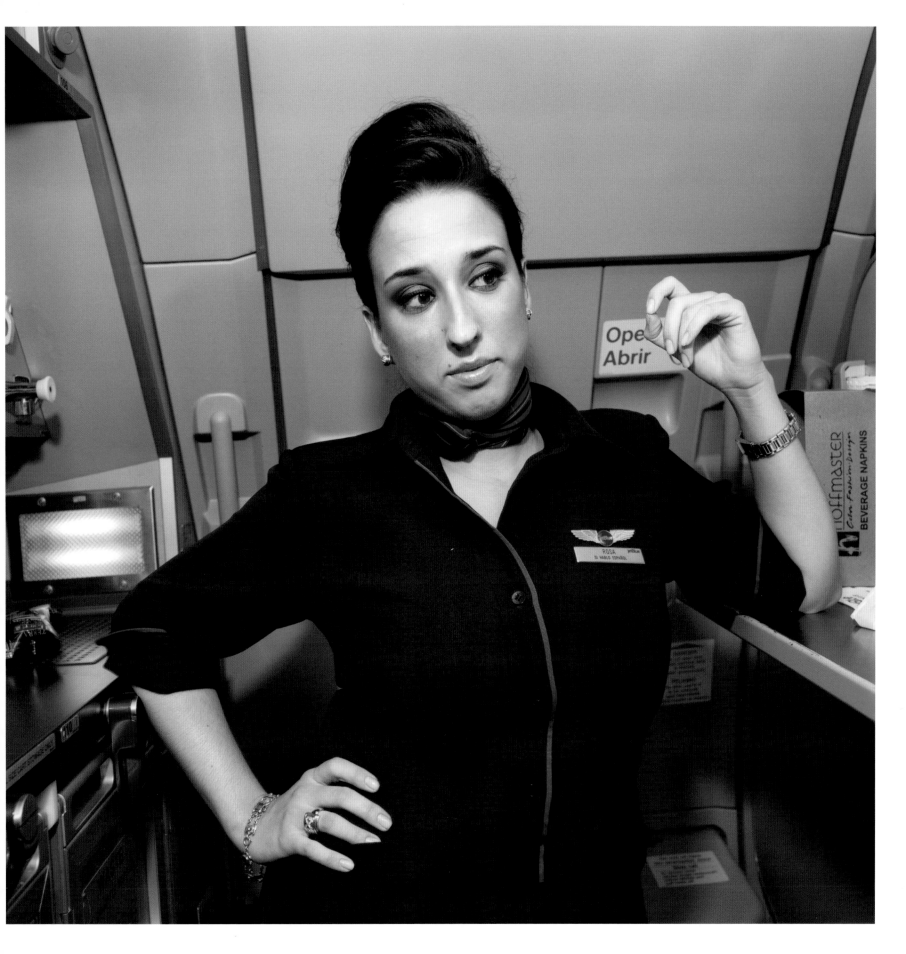

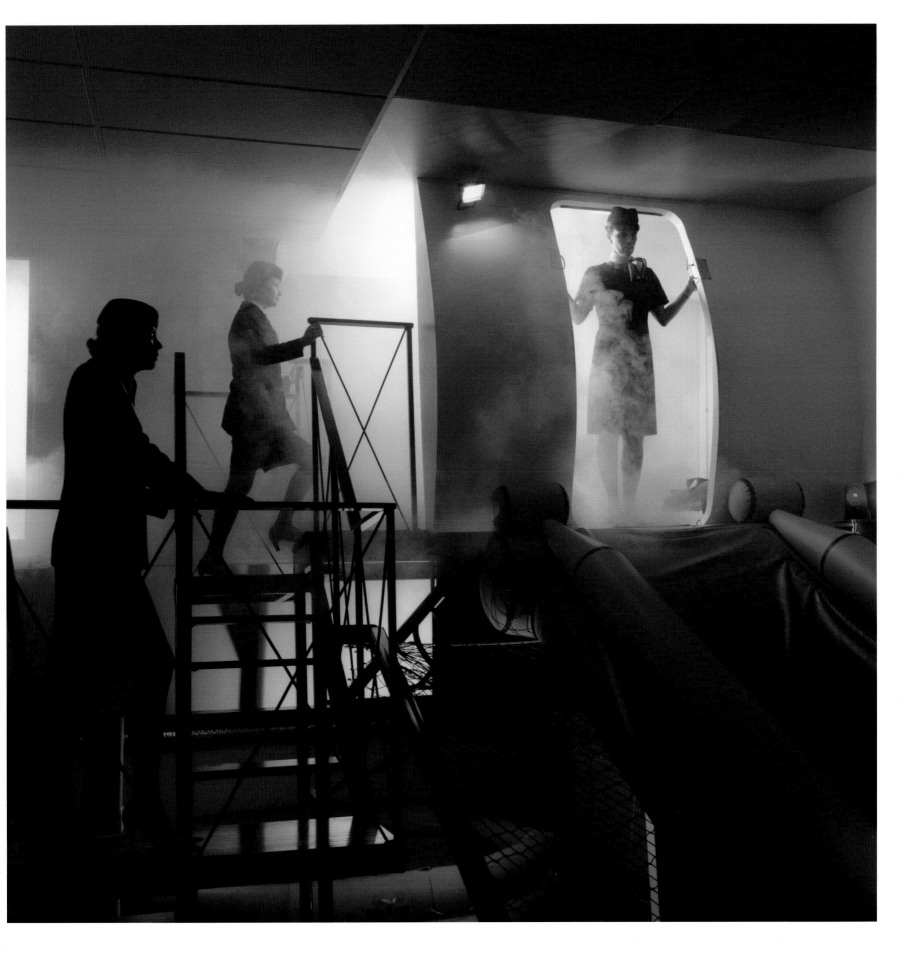

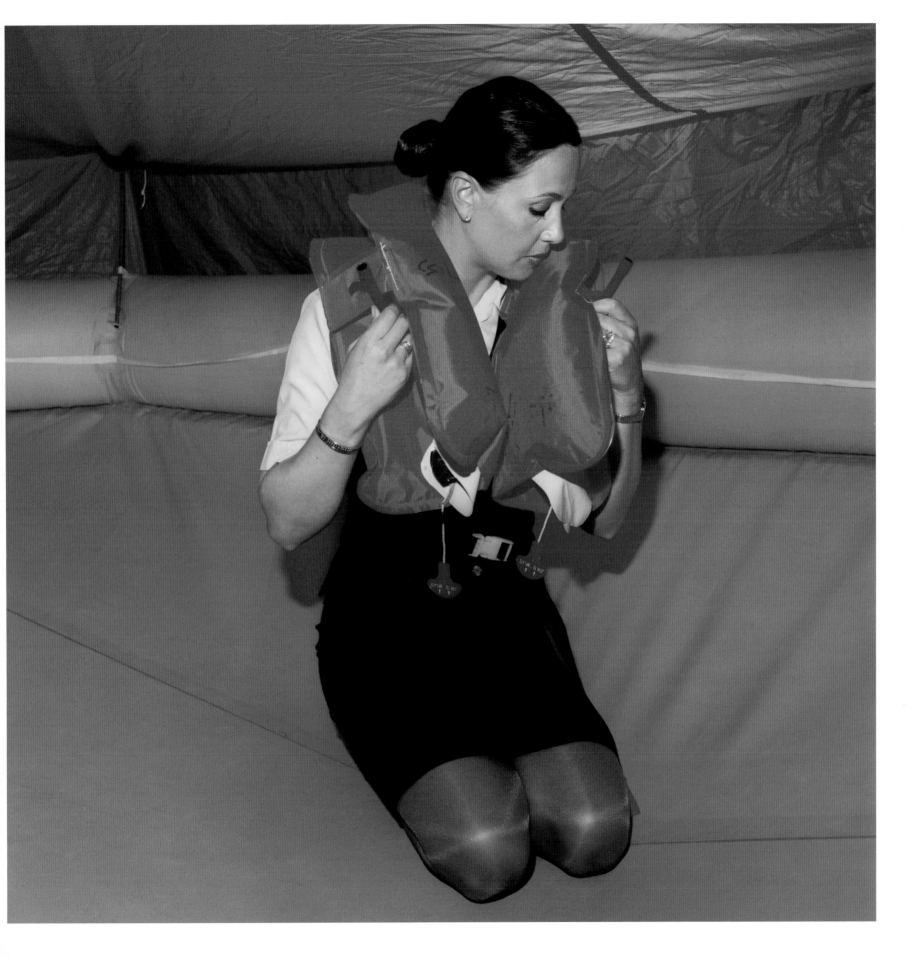

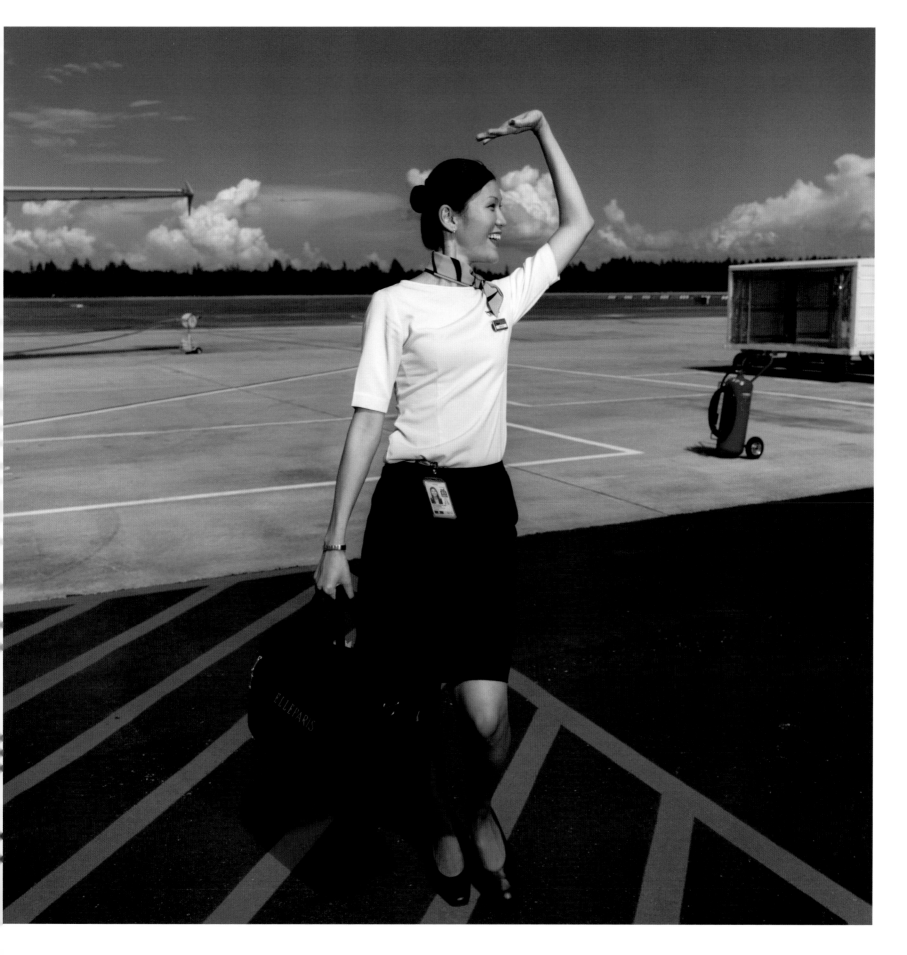

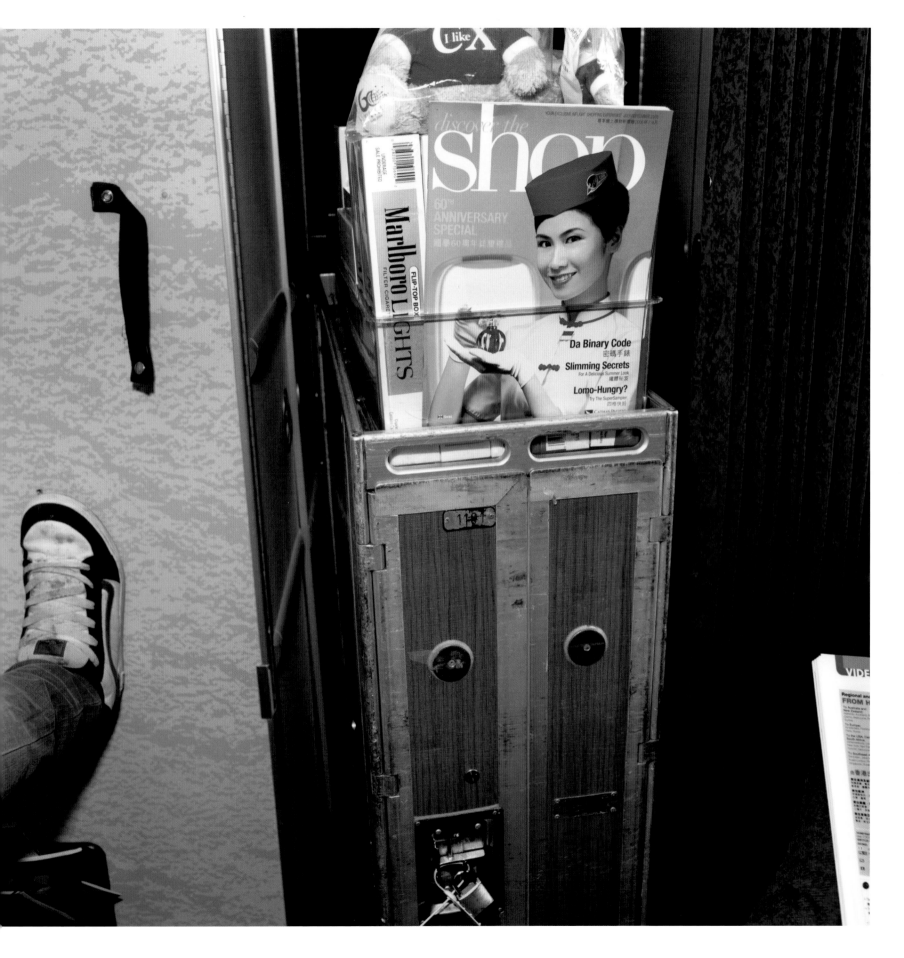

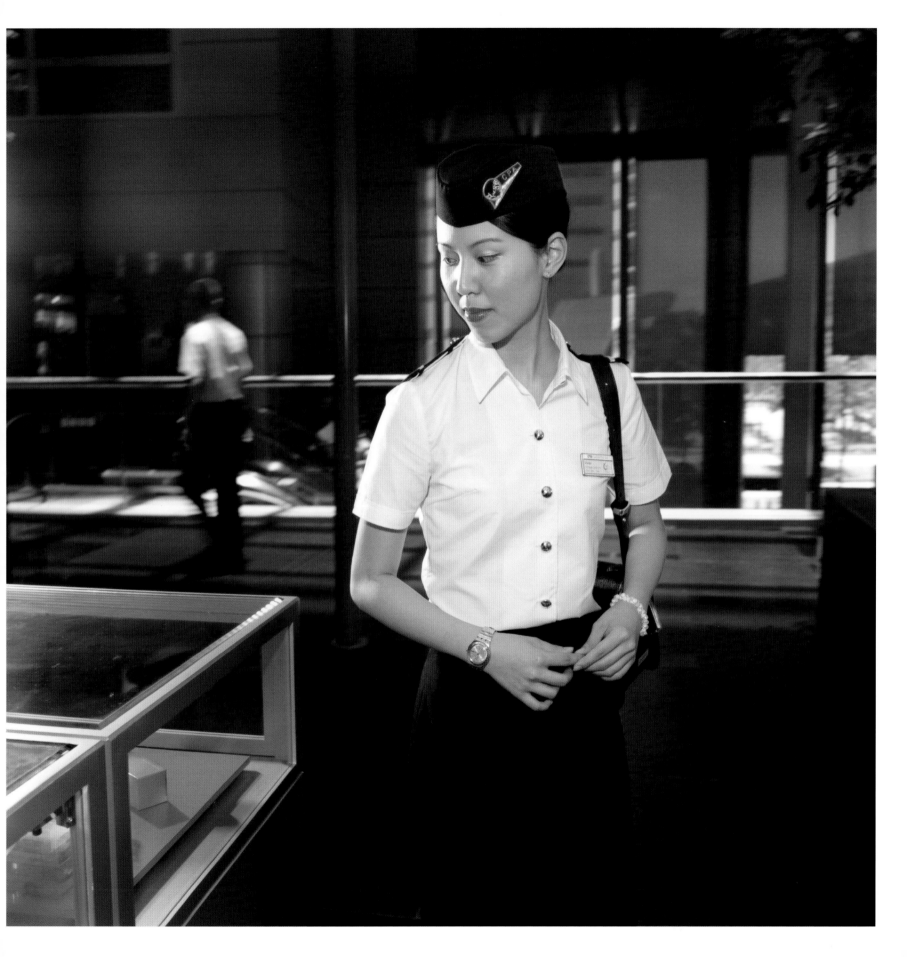

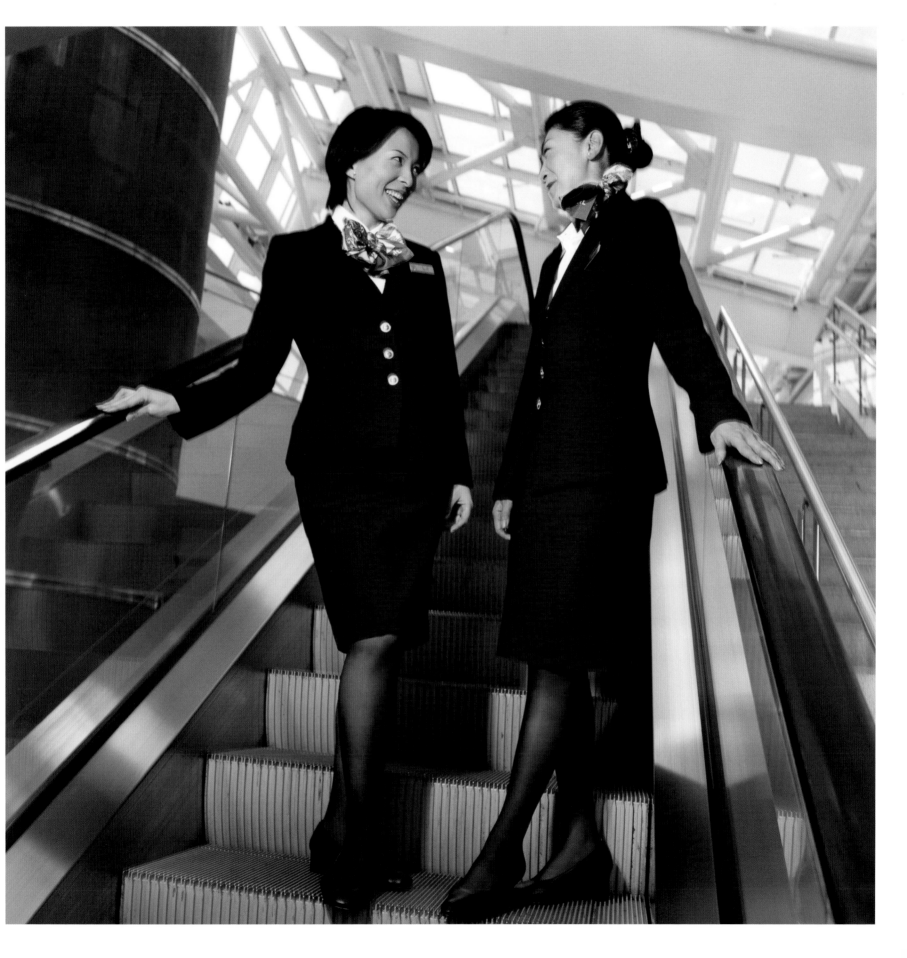

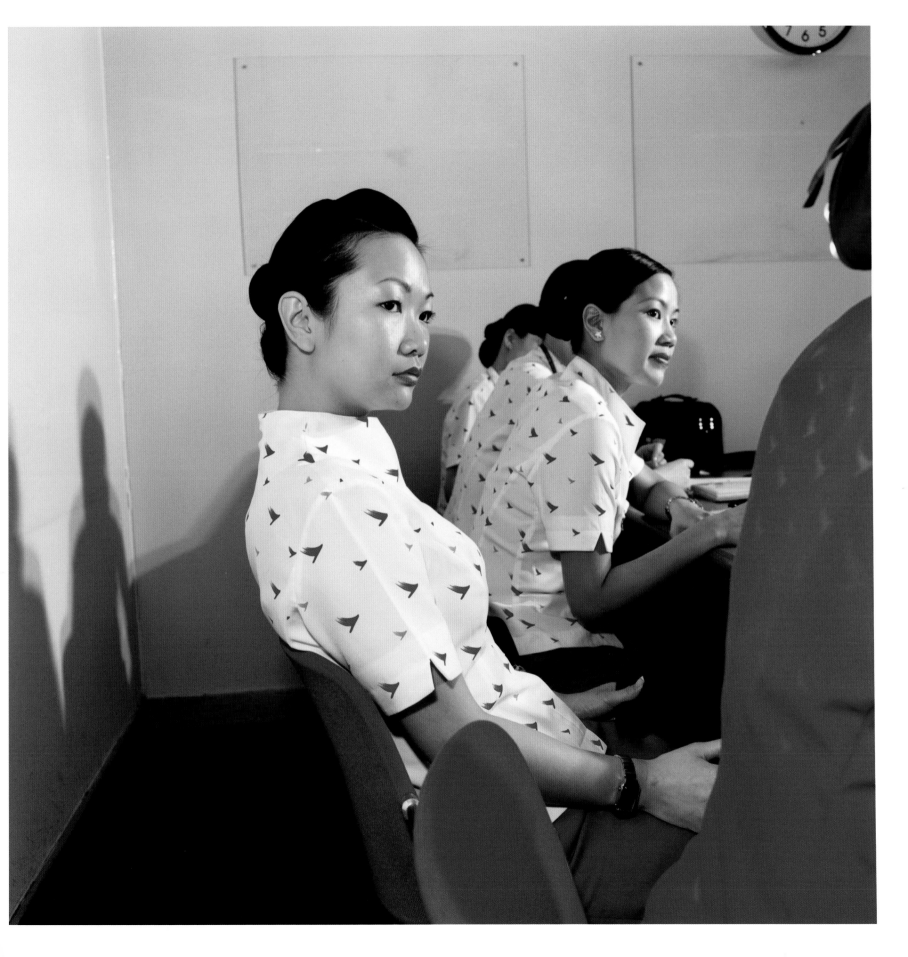

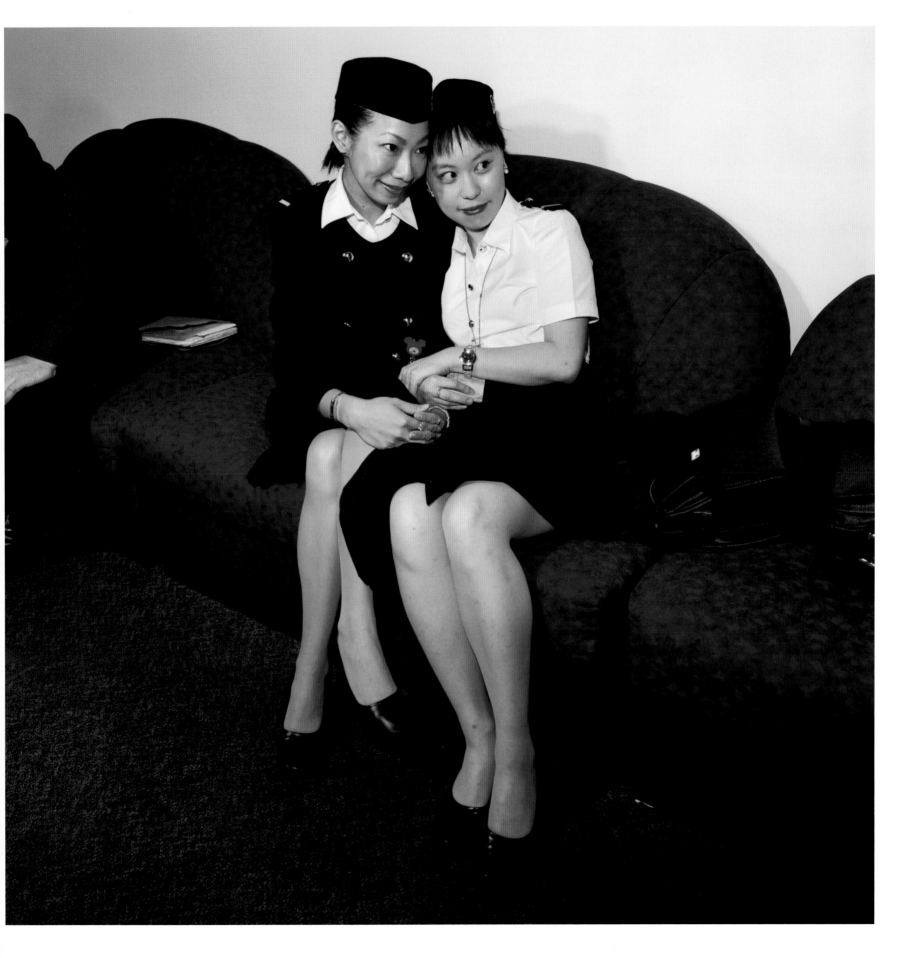

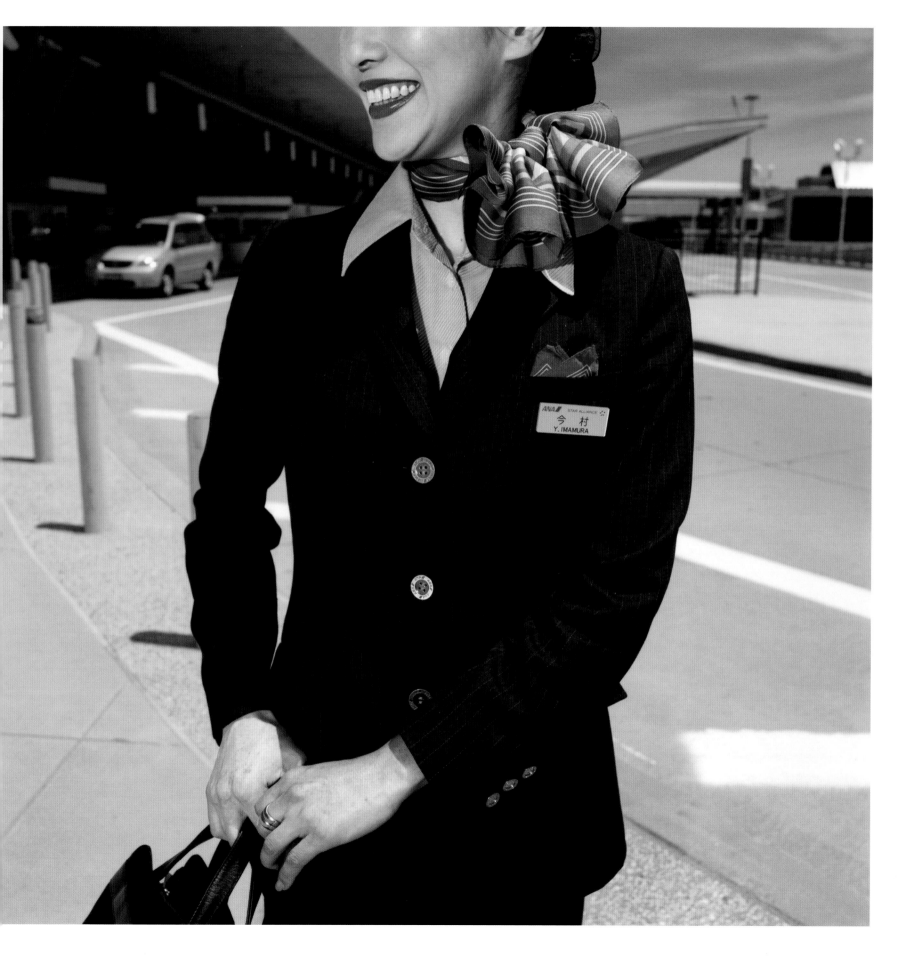

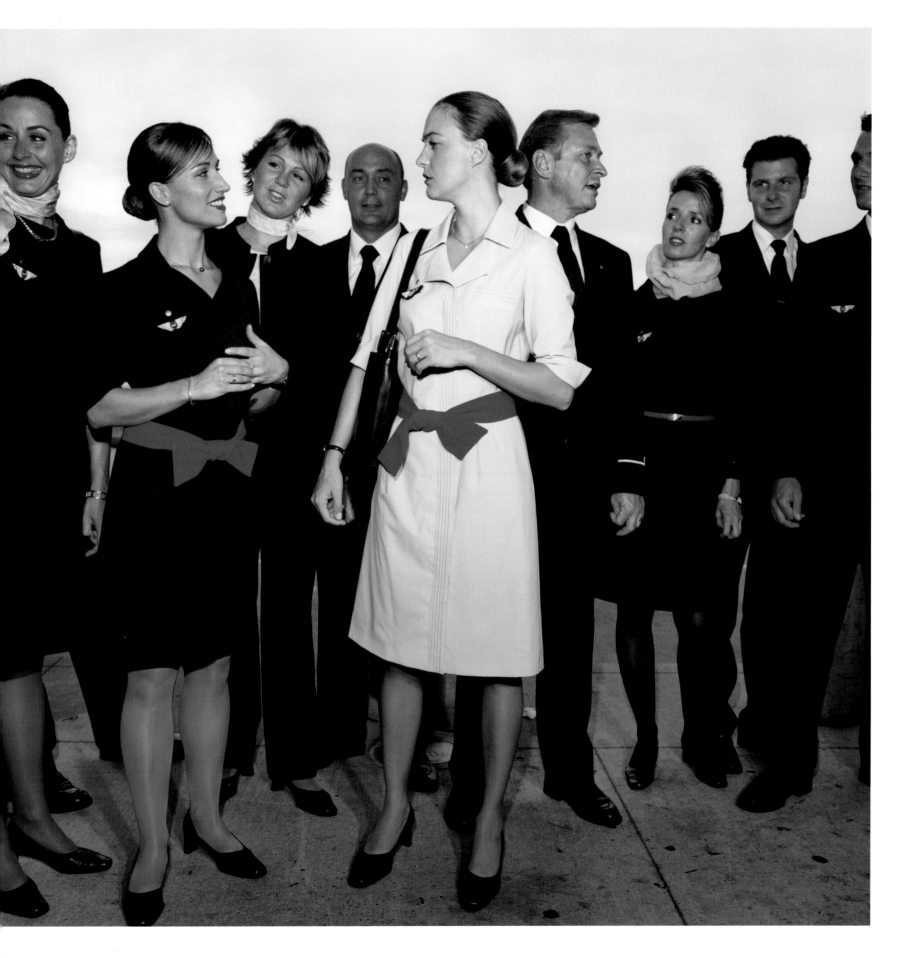

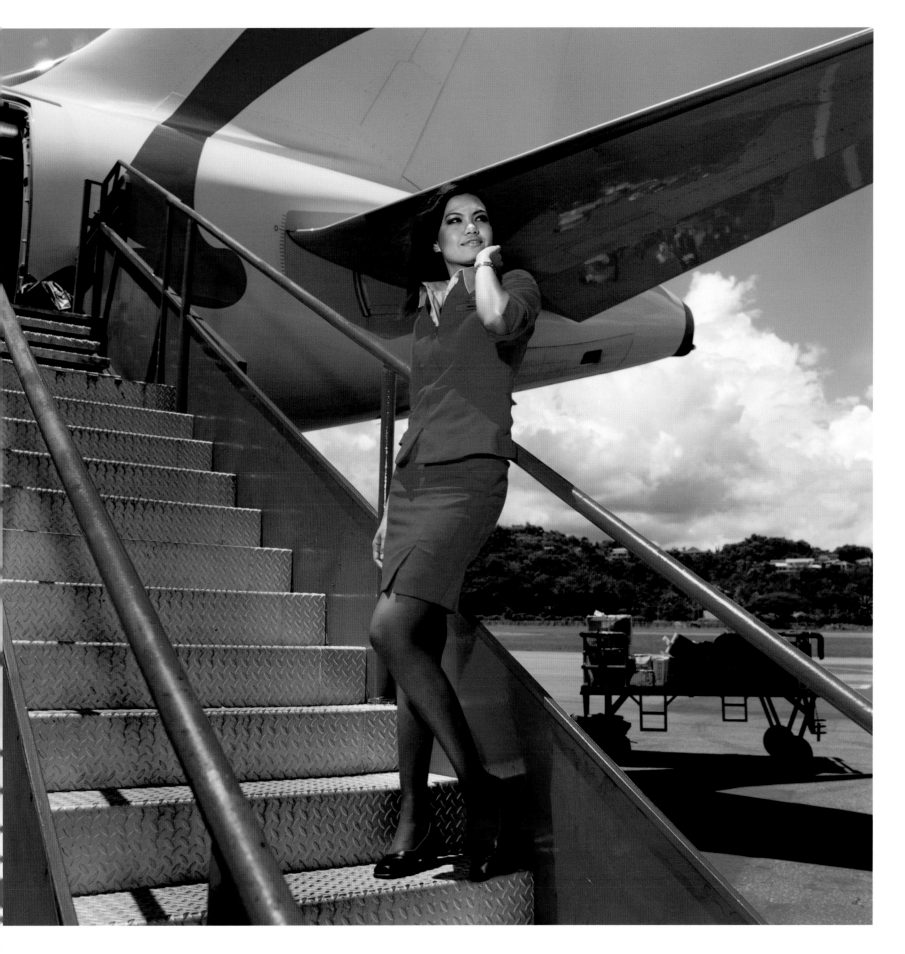

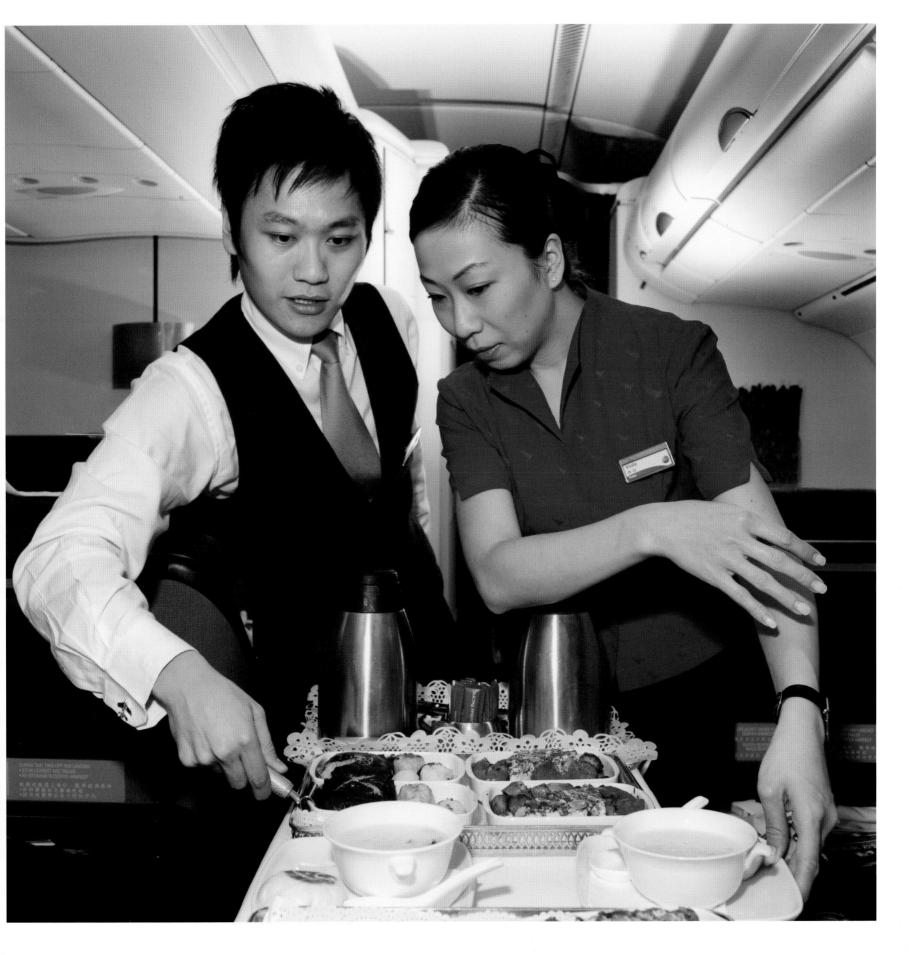

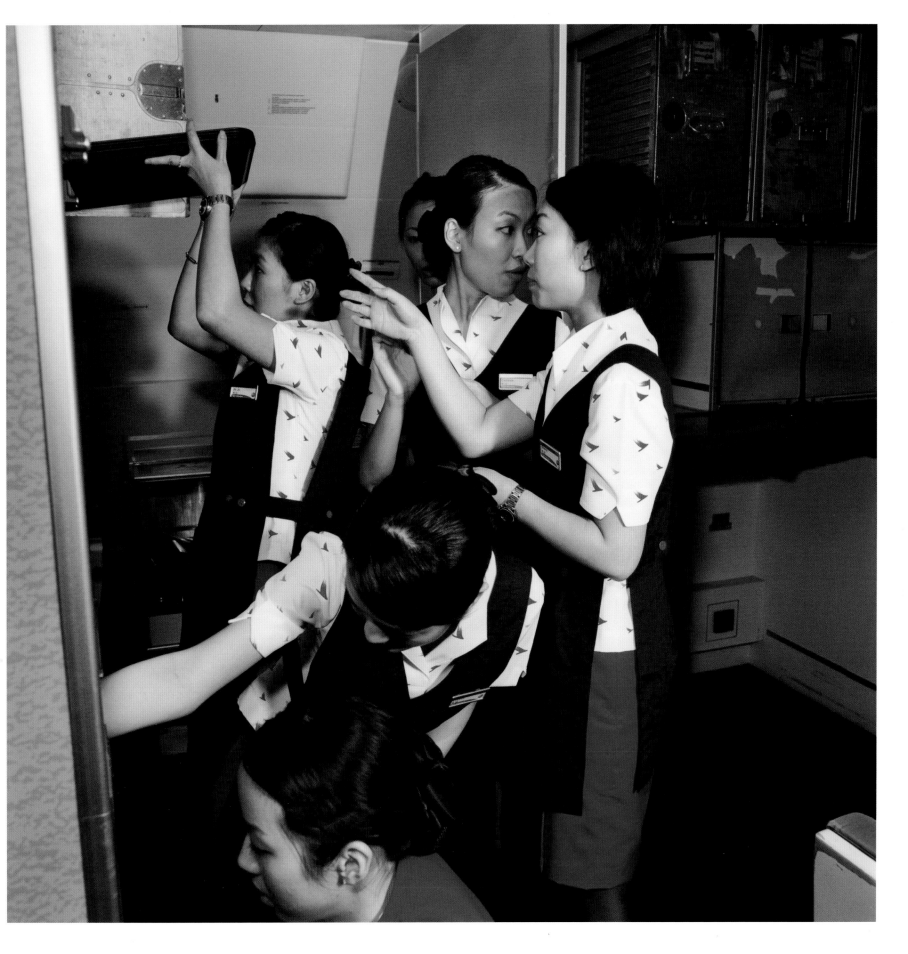

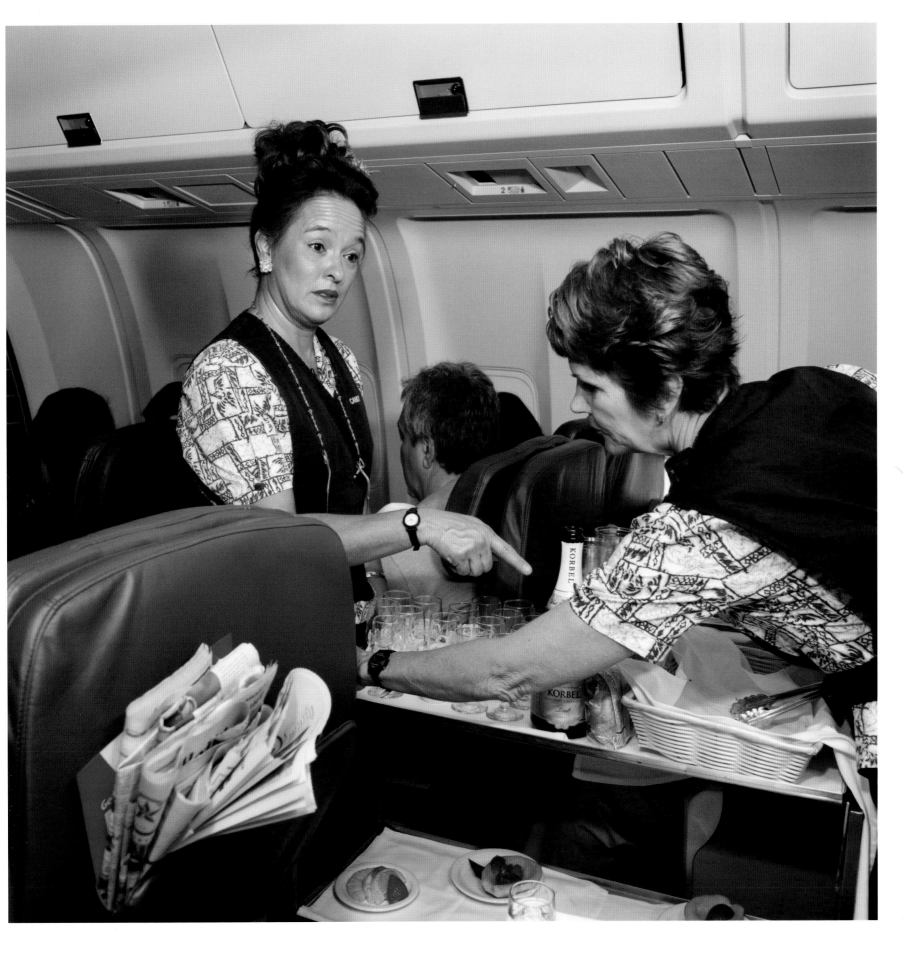

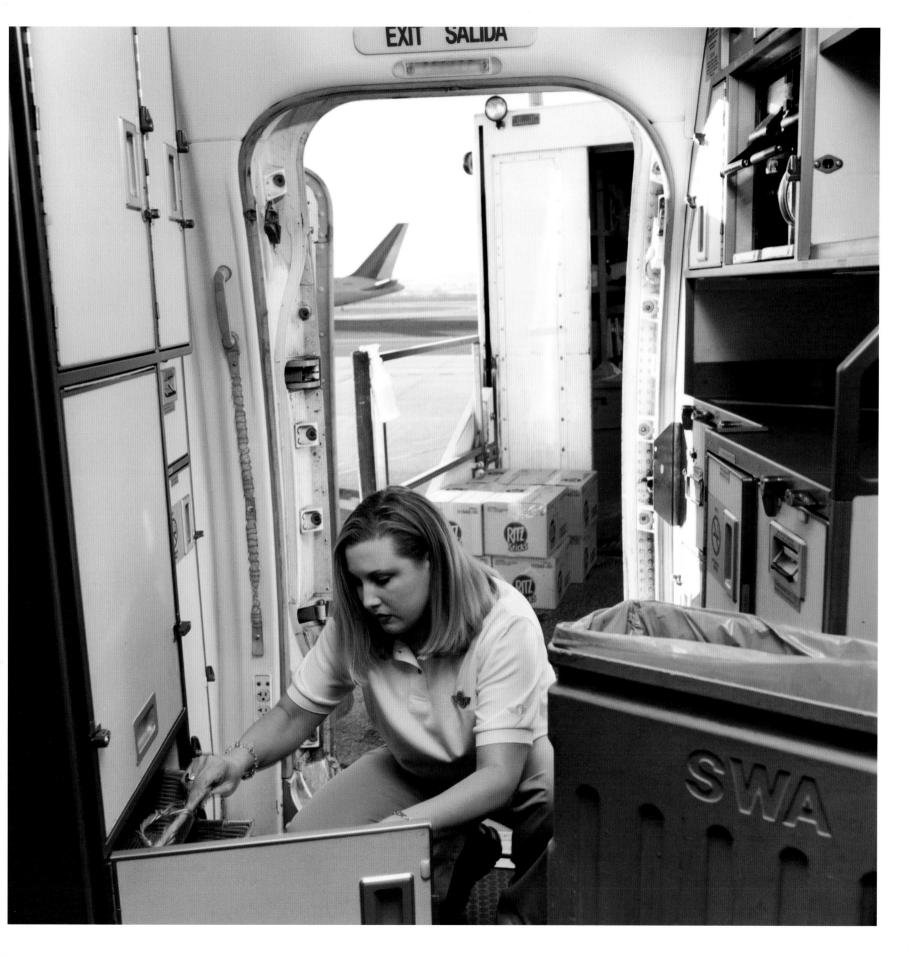

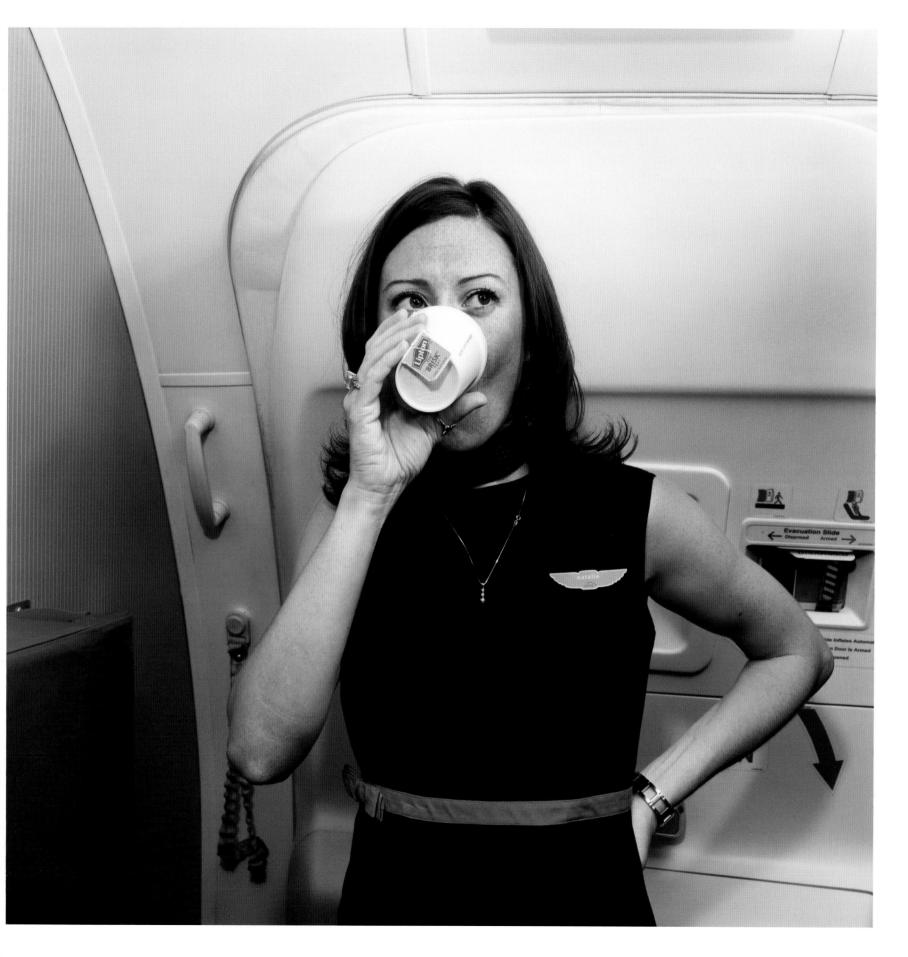

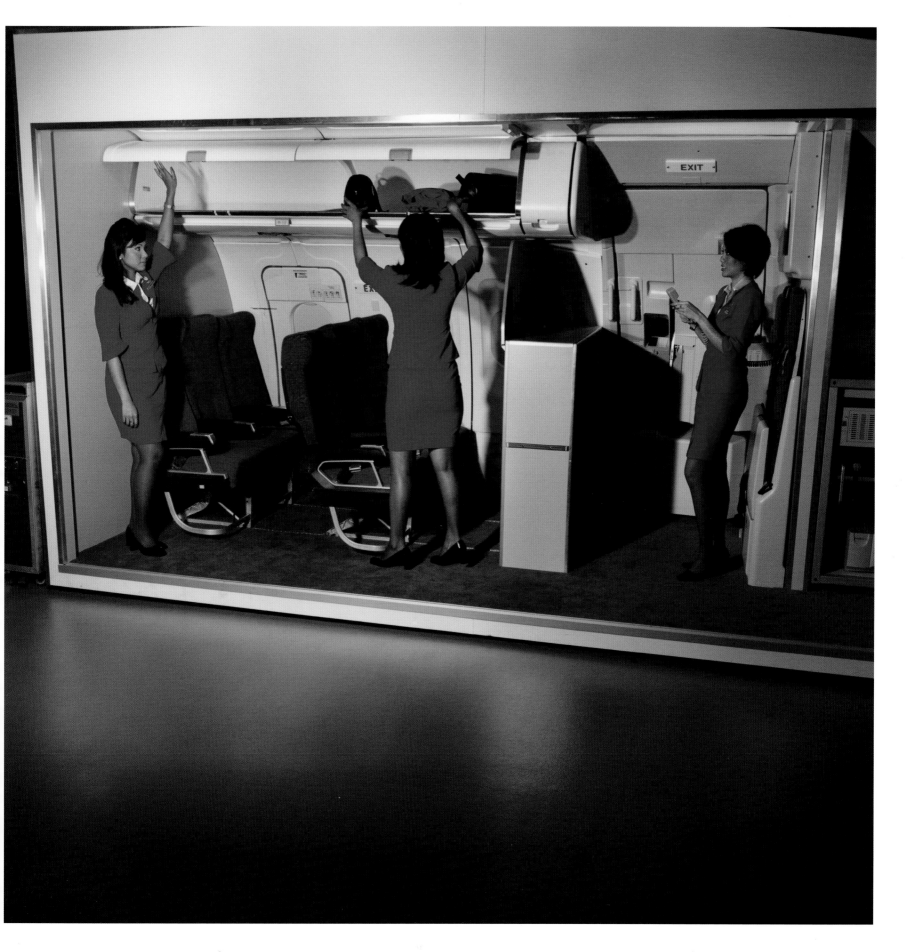

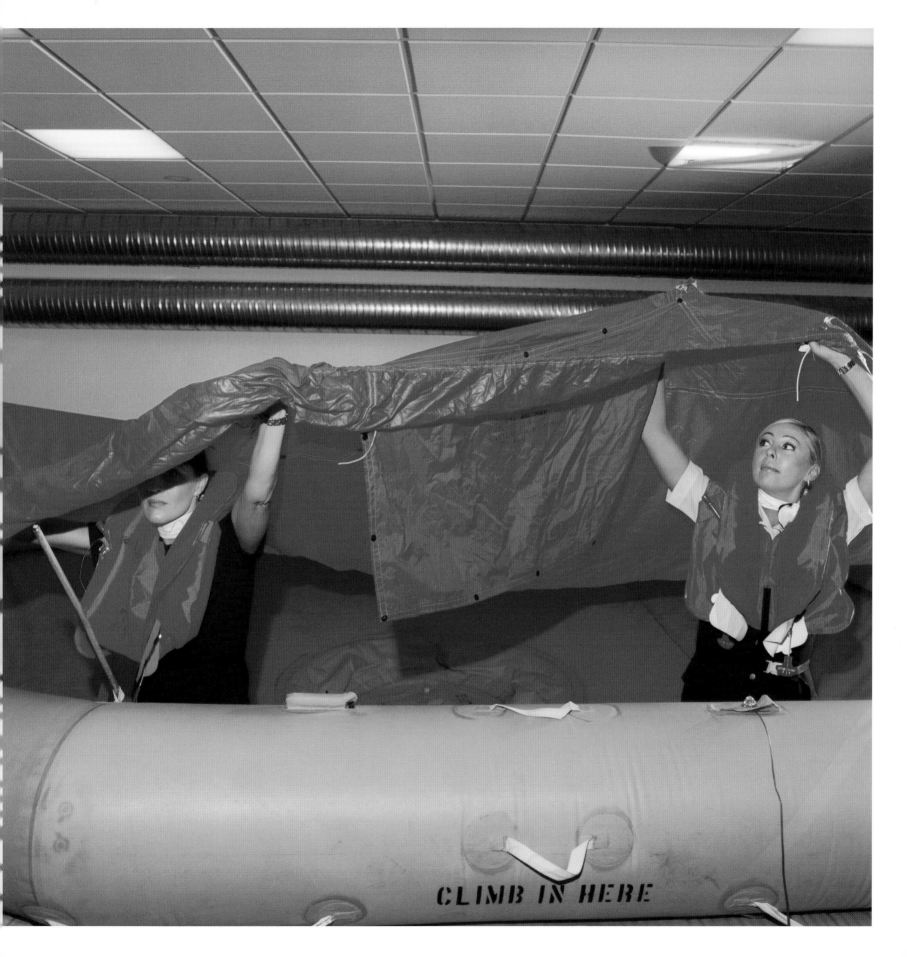

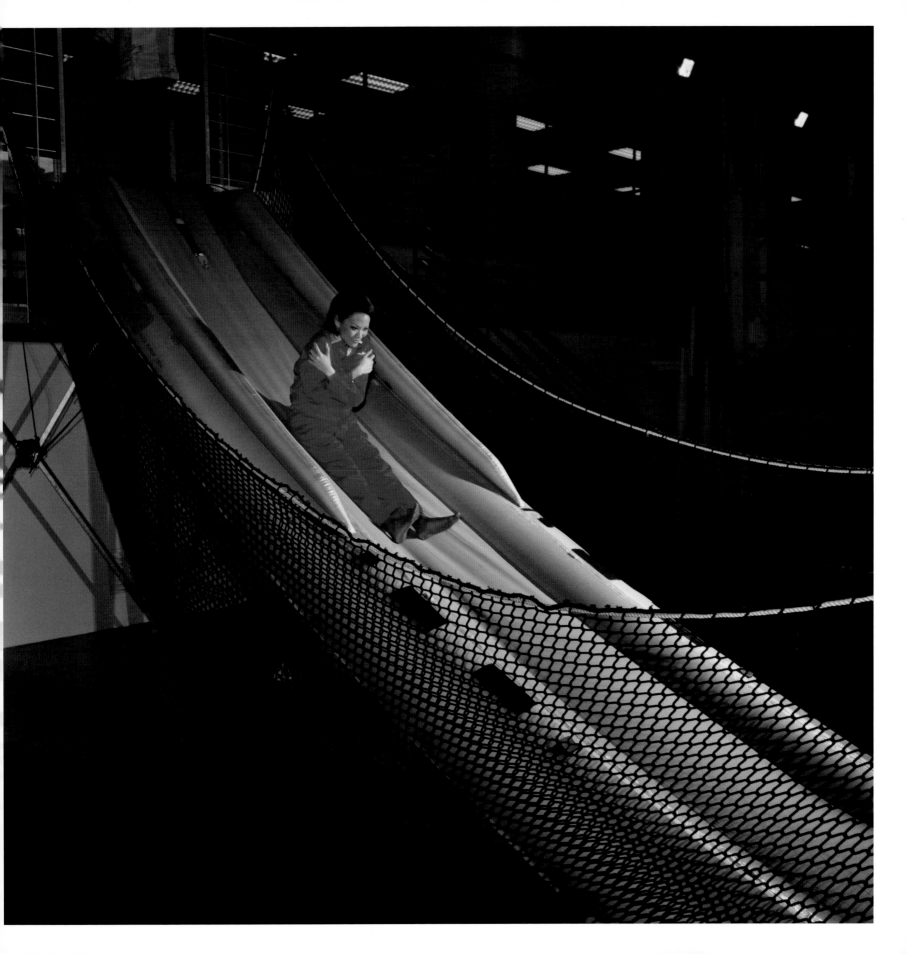

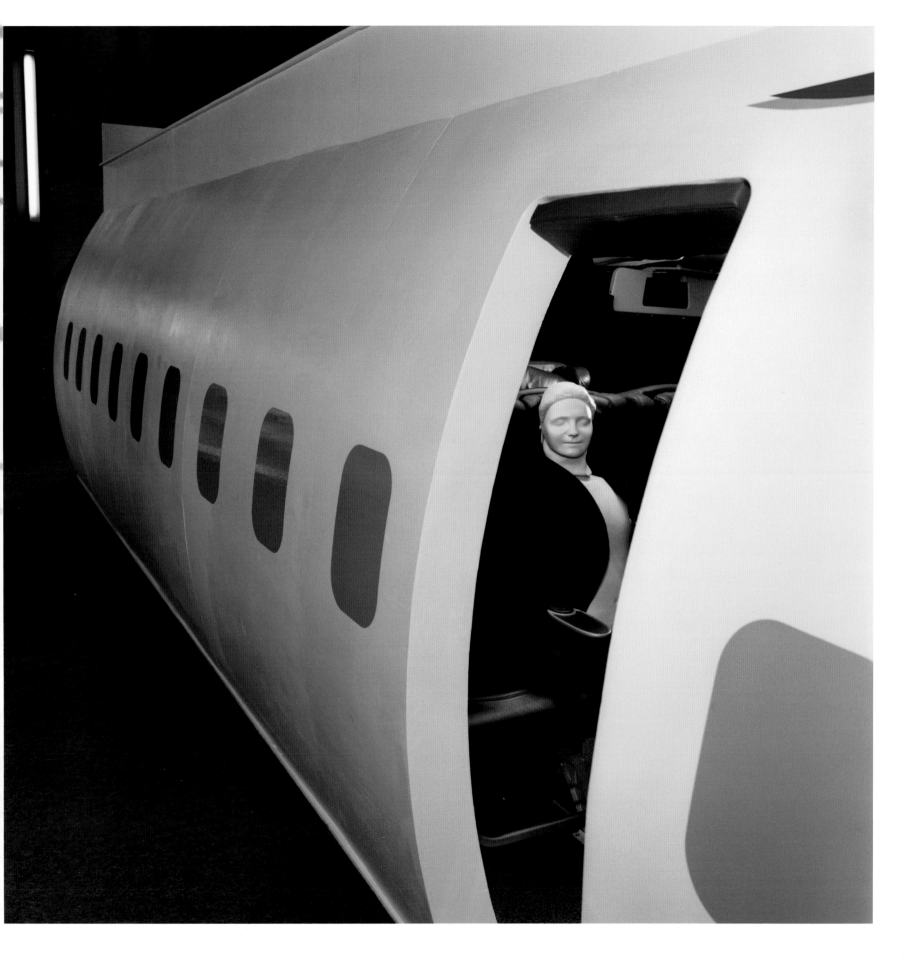

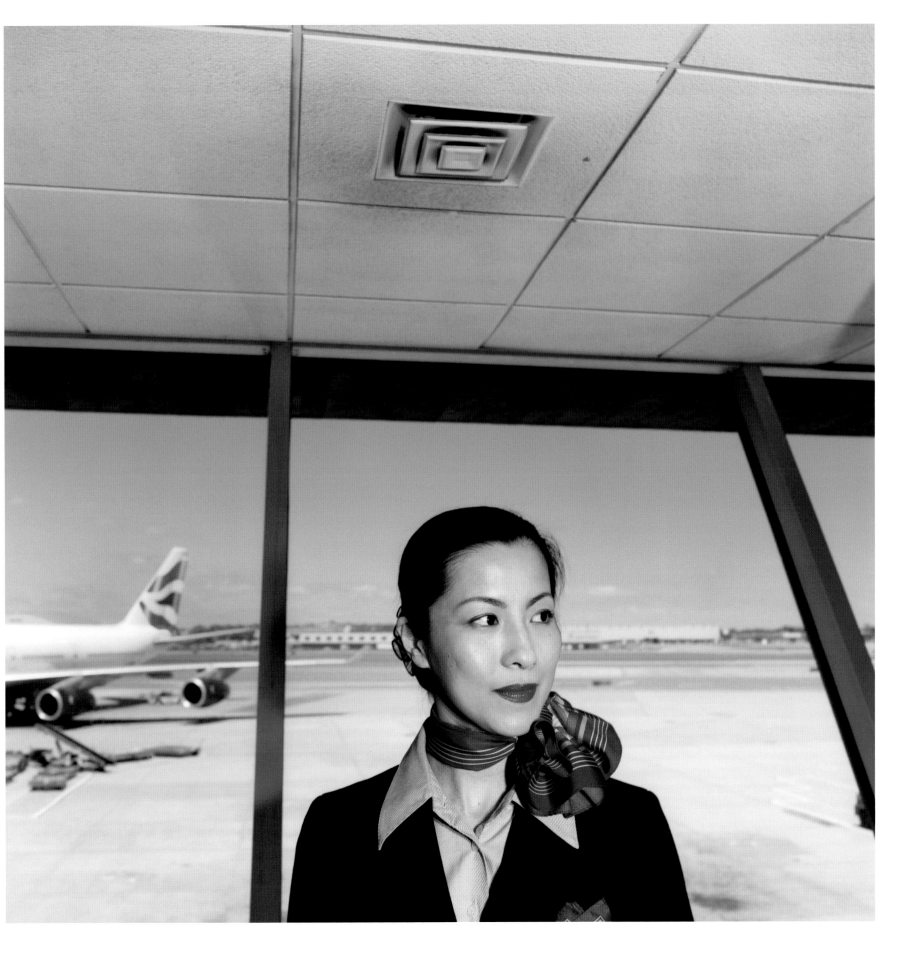

// Patsy and Kelly, Hawaiian Airlines

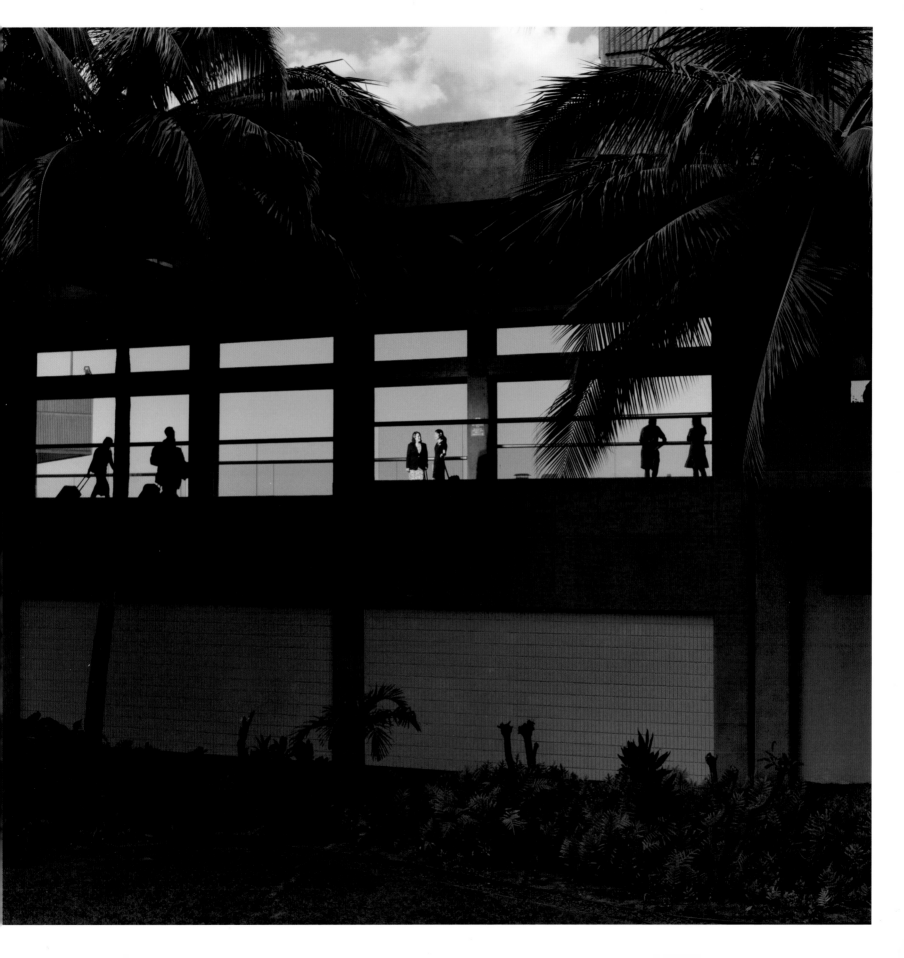

The camera has long been used as a tool of ethnography. Photographic vision has an uncanny ability to be simultaneously particular and generic in that it records specifics of individuals while ineluctably turning them into types, stereotypes, icons, and examples. Brian Finke's creative study of flight attendants offers us precise portraits of individuals, but it is also a study of a group—one might even say tribe—complete with idiosyncratic rituals, costumes, language, and behavior. It is not impossible to imagine Margaret Mead arriving with innocence and industry to the land that flight attendants inhabit, armed with camera, notebook, and tape recorder to undertake the kind of fieldwork that attempts to capture the reality of a people and create a definitive scientific overview. Even in the early years of ethnographic imagemaking, Robert Flaherty reminded us that to tell the truth, one often needed to distort it.

This polished and exotic tribe of flight attendants may cry out for ethnography, but the photographic vocabulary Finke has chosen owes more to the visual languages of fashion and advertising than to those of science or documentary. In their lighting and postures, the figures that Finke places within his frame appear staged, stylized, idealized and not quite human, a fitting match between a subject and its expression. Many of the images of flight attendants at work appear to show them in training. The ironic juxtapositions of perfectly groomed and tailored characters practicing their skills on beige and nearly featureless mannequins heightens the project's unreality. The number of images featuring plane safety exercises—often in patently artificial circumstances like a cutaway cabin installed at a warehouse-like site—underscores the aura of performance. The life jacket demonstrations, which we all experience as the inevitable opening ceremony of each flight we take, seem particularly absurd here, artificially lit and brightly colored, the participants frozen in mid-gesture.

Finke shows us several of his flight attendants in what pass for natural surroundings. To be sure, it is a clichéd tropical paradise which serves as their backdrop, complete with palm trees and perfect blue skies, making us think of dream holidays and tourist brochures. The flight attendants complete the cliché. Their job here is to decorate the landscape, whether walking across the tarmac with rolling suitcases, or cheerfully ascending or descending the flight of stairs leading to the plane with impeccable smiles and carefully wind-styled hair. Like the figures on billboards and in magazines so often used to brand one flying experience over another, these young women are there to be looked at. It is not unlike their role in the air. Of a piece with this are the number of photographs related to the grooming rituals of getting ready to perform the flight attendants' mythic and stylized roles. We see ironing, combing, eyebrow shaping, and the application of makeup in the ubiquitous mirror, all in the defining and idealizing light of movie sets and ad campaigns. Other images

show the finished products at work, serving food as stylized as they are, and performing their rote rituals of life jackets and rubber slides to save us from our fiery deaths at sea. If they appear at any point to be discomfited or frazzled by their work demands, it is also slight and stylized: a lock of hair out of place or a slightly tense expression.

Perhaps the most uncanny images in Finke's study of this strange tribe that we think we know are those that show flight attendants outside of the familiar contexts of polyester upholstery and graphic call buttons in the stylized shape of uniformed females. Here, attractive young women, distinctively garbed as a little bit soldier, a little bit fashion model, and a little bit schoolgirl, do the ordinary things we all have done: leaving an apartment, buying a toothbrush, playing billiards, or picking up a kid from daycare. The absurdity of both their circumstances and ours is exaggerated here. In these pictures we recognize that our world includes both these strange inhuman beings and ourselves.

In several of Finke's images, individual flight attendants are reduced to abstractions by croppings that omit the face, concentrating on such details as buttons and hands. Much of the way flight attendants are publicly presented serves to accomplish this too. I fly a lot, often taking the same weekly flight with the same crew, but their individuality eludes me. They are part of the plane and the experience of the plane, inhabiting, with me, a strange and somehow comforting neutral performative space in which we know our assigned parts. I know they have other, larger, more varied lives, but there, on the plane, doing their work, making their scripted announcements, they are intended not to connect with me in a personal way.

All of us who fly are somewhat inured to the absurdity of contemporary travel. We accept the ridiculous and humiliating experience of having to walk through metal detectors barefoot and jewelry-free, armed with less than three ounces of shampoo, bereft of tweezers, nail clippers, and night club souvenir matchbooks. We know that what will follow is a weird rote speech by a bizarre uniformed being who temporarily controls us, followed by a serving of pretzels and lukewarm plastic-bottled water.

Representation of labor has changed significantly since Lewis Hine's powerhouse mechanic embodied simple strength, virility, and quotidian heroism. To be sure, labor itself has changed; the service economy makes little but produces much. In addition we are not as innocent as Hine may have been. Now that everything is fair game for the camera, we can allow its products to be true, false, fiction, lies, dreams, creations, interpretations, fabrications, and poems. Finke, whose previous ethnographic excursions have studied cheerleaders and football players, has an eye for performance and the telling detail, for costume, posture, gesture, and expression. His exploration of air workers leaves us with both a document and a historical novel, both set in our time.

⬛ Acknowledgments

My deepest thanks to my wife, Lisa Daniels, for her artistic collaboration, and to both her and our son Oli for their support, inspiration, and love. I want to thank James Leighton for his talents while photographing, and for his beautiful interpretation of the images in the darkroom. These photographs were made possible with help from the following photography editors: Peira Gelardi, Fabrice Frere, Sarah Greenfield, Maisie Todd, Paul Moakley, and Meaghan Looram. Thank you to Alix Browne and Alison Nordström for their wonderful words and to Brian Clamp, Philippe Chaume, Ross Kasovitz, and Ed Osowski for their continued guidance and support. Thank you to Craig Cohen, Daniel Power, and Sara Rosen of powerHouse Books and to Patrick Le Bescont of Filigrane Editions for realizing this book, and to Mine Suda for her elegant design.

Thanks to the following airlines for making this book possible—Air Asia, Air France, All Nippon Airways, British Airways, Cathay Pacific Airways, Delta Airlines, Hawaiian Airlines, Hooters Air, Icelandair, Japan Airways, JetBlue Airways, Qantas Airways, Song Airlines, Southwest Airlines, Thai Airways, and Tiger Airways.

Raised in Texas and schooled in New York, **Brian Finke** defined himself as a documentary photographer at the World Press Photo Masterclass in 2001 and was awarded a New York Foundation for the Arts Fellowship for Photography in 2004. The author of *2-4-6-8: American Cheerleaders and Football Players* (Umbrage Editions, 2003), Finke has also exhibited his work in New York City, Los Angeles, Paris, Chicago, and Houston, among others. Finke lives in New York City with his wife Lisa Daniels and son Oli.

Alix Browne is the Deputy Style Editor of *The New York Times Magazine* and a freelance writer based in New York City.

Alison Nordström is the Curator of Photographs at George Eastman House International Museum of Photography and Film in Rochester, New York. Previously the Director and Senior Curator of the Southeast Museum of Photography in Daytona Beach, Florida, she has curated over 100 photographic exhibitions and is the author of several monographs as well as numerous articles in scholarly journals. She is particularly interested in contemporary art that mixes media and disciplines, and in projects that trace the histories of representation. Nordström holds a BA in English Literature, an MLS with museum emphasis, and a PhD in Cultural and Visual Studies.

Flight Attendants // Brian Finke

© 2008 powerHouse Cultural Entertainment, Inc.
Photographs © 2008 Brian Finke
Text © 2008 Alix Browne
Text © 2008 Alison Nordström

Published in the United States by powerHouse Books,
a division of powerHouse Cultural Entertainment, Inc.
37 Main Street, Brooklyn, NY 11201-1021
telephone 212 604 9074, fax 212 366 5247
e-mail: flightattendants@powerHouseBooks.com
website: www.powerHouseBooks.com

First edition, 2008

Library of Congress Control Number: 2007941958

Hardcover ISBN 978-1-57687-427-1

Printing and binding by Midas Printing, Inc., China

Book design by Mine Suda

A complete catalog of powerHouse Books and Limited Editions is
available upon request; please call, write, or return your seat back
to its upright and locked position on our website.

10 9 8 7 6 5 4 3 2 1

Printed and bound in China